ht to his images. All

both, 25, 36, 66 left,
8 right, 80 top left, 89
111 top left, 111 right,

left, 79 right, 86 left,
m left, 100 right, 101
m, 111 bottom left,
right, 118 top left, 119
top left, 128 left, 130

top right and left, 57,
0 bottom left, 86–87,
4 left, 125 bottom left,

81, 82–84, 85, 108 top,

bottom, 120–122,

19 left, 20, 21, 26, 30,
52, 53, 67, 98 right

59

h, 63, 90 both, 91 all,
om, 101 bottom right,

64 both, 65 both

ght and left, 74 bottom
center, 78 bottom right,
ht, 89 bottom left and
tom left and right, 123,
t, 130 top left, 131

t, 74 top left, 74 right,
ight, 77 right, 78
9 right, 100 left, 103,
op right, 119 top center

hs courtesy of the
rt, except those on page
Rasmuson Library,

CONTENTS

LAND OF PERIL AND PROMISE

LANDMARK LANDSCAPES

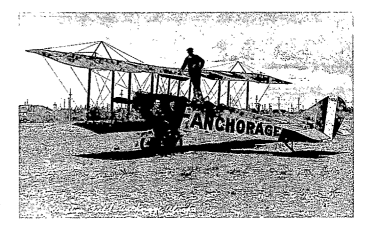

FROM WONDER LAKE, the white triangle of Mount McKinley stands like an immense monument. In sheer mass, this highest of all the continent's mountains is probably the largest single object most people who behold it will ever see. It floats up where the clouds belong, usurping a big part of the sky.

Each summer morning photographers stop by the lake to catch the classic image of the mountain, this symbol of Alaska that has been recorded so many times. Professionals with special permits set up tripods along the gravel national park road. Tourists climb from buses amid the hush usually reserved for church, cameras at the ready, attempting to preserve the moment. In a few minutes, everyone reboards and the bus grinds on down the road. The light changes and the professionals pack up for their next stop. Another bus stops, and another group gets off. Passing like clouds that drift on summer breezes over the face of the mountain, people enter and leave this grand space, try to capture it in a moment, and are gone.

If it were possible to stand back and shoot this same picture once a day for ten thousand days, only the white mountain would stay the same. The tundra would change colors with the seasons, the way the sky changes through the day. The migrating caribou would pour rhythmically back and forth across the images. Pulling the camera back to see the whole state, McKinley would appear as just a tiny ripple among thousands. Using time-lapse photography to show ten thousand years since the last ice age, when the land emerged from a solid sheet of glaciers, all of Alaska's recorded history would disappear into a tiny blink, a mere speck on the last few pictures in the series. In Alaska, civilization is an afterthought, ridiculous in comparison to its setting.

Civilization began dividing up the earth's surface and deciding what belonged to whom centuries ago. Alaska, a land richly endowed with natural resources and the majesty of untamed natural power, was one of the last spots on the globe to remain unclaimed. The pioneers who came to Alaska during the first century that it was American territory may have dreamed of settling the country as the West had been settled, but by the centennial of the Alaska purchase in 1967, more than 99 percent remained wild.

THE LAY OF THE LAND

Geography, weather, and the extremes of the natural environment explain why Alaska remains unsettled. To the north, the land is an Arctic desert. North of the Brooks Range, where the North Slope gradually ramps down to the Arctic Ocean, only a thin top layer of tundra and water thaws for a few months of summer. The ground underneath remains frozen year-round, as it has for thousands of years, a condition called permafrost. Not much rain or snow falls, but water that cannot penetrate the frozen layer stands on the surface, forming huge, shallow ponds divided by thin, insubstantial heathery strands of soggy tundra. Many of Alaska's ten million lakes are here, hosting much of the hemisphere's population of migratory waterfowl during the summer. Immense herds of wild caribou calve on this coastal plain. Development is expensive to impossible: structures melt into the ground unless built on refrigerator coils or other devices to dissipate their own heat; sewer and water utilities cost a fortune to build and maintain in the frozen swamp. In Barrow, the northernmost town, the sun never sets for eighty-four days in summer, and never rises for the same length of time in winter. Barrow's average daily high temperature in February is -12ºF.

The Brooks Range forms the continental divide between Alaska's Arctic and Interior regions. The Interior, or vast, sparsely developed central part of the state, contains North America's highest mountain, 20,320-foot Mount McKinley, and the nation's third-longest river, the 2,400-mile Yukon. Temperatures in the Interior are the state's most extreme, ranging from a record high of 100ºF to a record cold of -80ºF. Most people live in the hub city of Fairbanks, and the balance in tiny towns, Native villages, and widely scattered homesteads, which are the only settlements punctuating broad, scrubby flatlands, regularly scorched by wildfire. The towering, tundra-flanked mountains of the Alaska Range, and especially McKinley's shimmering triangle of white, draw hunters, fishermen, hikers, river floaters, and even mountain bikers in the summer. But in the winter humanity withdraws, leaving the cold, stormy darkness to the wolves, moose, and denning bears.

Southern coastal Alaska is another world. The mountains that rise from the ocean here catch clouds off the Pacific Ocean, releasing their moisture in heavy dumps of snow and rain and feeding a forest of great trees ranging from Kodiak Island south and east to British Columbia. This is the land of salmon and huge, salmon-fed bears. Mountain-carving glaciers flow from the coastal highlands under the immense weight of thousands of years of accumulated snow, dropping house-sized chunks of blue ice into deep ocean fjords. On the northern

Gulf of Alaska coast, near Anchorage, Alaska's largest city, the outer shoreline is wild and storm-battered. But within protected waters of Prince William Sound, Cook Inlet, and the many bays and inlets of the Kodiak Archipelago and Alaska Peninsula, rich salmon fisheries send small boats out from the coastal towns on summer days. Sea kayakers explore the gravel beaches of uninhabited islands and long fjords. Just behind the rain shadow created by the coastal mountain peaks, the dry extreme weather of the Interior still prevails, but here along the coast, temperatures are moderate, rarely dropping below -20ºF on the coldest winter nights.

Farther south and east, the coast is broken by the elaborate island pattern of the Southeast Alaska Panhandle, so-called for its shape on a map of the state. The large, thickly wooded islands protect the Inside Passage, a corridor of fjordlike channels that allow cruise ships and other vessels to run the length of the region from Metlakatla to Skagway without danger of hitting a significant wave. The weather is temperate and rainy, more similar to the Pacific Northwest than to the rest of Alaska. The towns of Juneau, Alaska's capital city, Sitka, and Ketchikan, along with many other, smaller seaside communities, sit on the mountainous edges of these channels, accessible only by boat or plane.

This is Alaska's most populated coast, with an economy that relies on fishing, tourism, timber, and government, but wilderness is still the dominant theme. In between the towns lie hundreds of miles of rugged shore-line, endless gravel beaches, towering granite cliffs falling straight to the sea, and protected, island-speckled waters of infinite complexity and biological productivity.

The Aleutian Islands extend more than 1,000 miles west into the North Pacific, all the way beyond the International Date Line and into another day. The volcanic Aleutians, clothed only in green heather, withstand pitiless wind, inescapable fog, and the driving rain of endless storms. Mostly uninhabited and impossibly remote, the islands still offer habitat to one of the world's greatest concentrations of exotic birds and other wildlife, as well as rich fisheries that support a booming economy in the industrial outpost of Dutch Harbor, based on commercial fishing, fish processing, fleet services, and transshipment of cargo.

EXPLORATION AND EXPLOITATION

Alaska's history is all about the struggle with this immensity. Some instances of this struggle are obvious: the great projects that have linked the state with the outside world and connected some of its parts, or the rush for gold and other natural resources and the difficulty of extracting that wealth. For some people in Alaska's history, the place was an empty page to be developed. For others, it was a finished masterpiece that mankind's work could

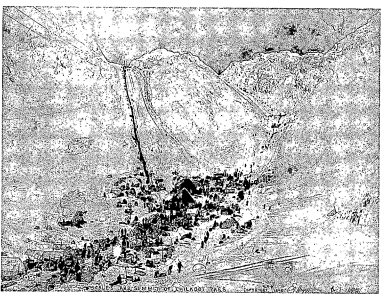

only diminish. Mountain climbers, explorers, naturalists, writers, and photographers came to experience and record Alaska's gifts. For some, Alaska was a fresh frontier, to grow and fill with people.

The first people who came to explore Alaska from outside saw it as a prize: its shorelines there to be sighted, named, and reported back to the crown. Vitus Bering, sent by Peter the Great to find the west coast of America and determine if it was connected to Russia, traveled a harrowing 5,000 trackless miles across Asia, from Saint Petersburg to Russia's Kamchatka Peninsula, where he built ships for the next phase of the journey. In 1728 Bering was the first white man to look upon Alaska, when he sighted what is now Saint Lawrence Island. Deducing that Asia and America were not connected, he didn't bother to land or approach the mainland, returning instead to Saint Petersburg to maneuver politically for support for another trip. That one finally took place in 1741, when his two ships made landfall on Kayak Island in the Gulf of

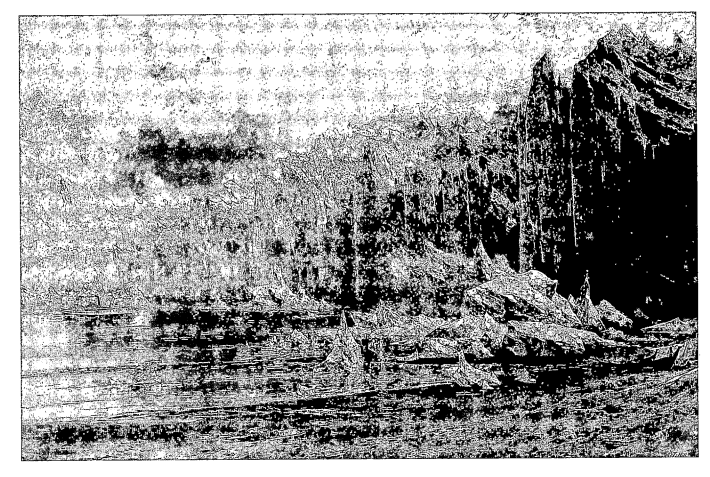

Alaska on July 16. The noted German naturalist Georg Steller was on board, but Bering permitted him only a few hours to collect specimens: he simply didn't care about the biology or people of the land he had discovered and wouldn't waste even a full day on such frivolous investigation. He ordered the ships to return to Russia, but the ship wrecked and Bering didn't live to win the glory of his discovery.

For the next fifty years most Russian incursions into Alaska were solely in pursuit of furs. The Aleuts, who were adept at encircling and spearing wily sea otters, were forced to provide the pelts that sold for princely sums in China. In return the Aleut culture was decimated—slavery and disease reduced the population by 80 percent. The sea otters had also been hunted to the point of eradication.

The British were also interested in the fur trade, but they were better businessmen than the Russians and far more successful. Instead of using force they bought the Natives' furs with superior goods and fair prices. Initially they didn't bother to build outposts, simply arriving in ships, but eventually the British-owned Hudson Bay Company built a network of trading posts that would threaten the Russian monopoly.

In 1778 British Captain James Cook surveyed much of the Alaska coast on a voyage with the true purpose of searching for a Northwest Passage connecting the Atlantic and Pacific oceans. Unlike Bering and others sent for cursory visits by France and Spain, Cook brought expert artists and mapmakers to record his findings. They produced detailed charts that were used for a century afterward and etchings that recorded Native ways before they were altered by widespread contacts.

Although the British and Americans signed treaties recognizing Russian control of Alaska in 1824 and 1825, respectively, these contracts were often honored in the breach by authorities too inefficient or disinterested to defend their territory. New England whalers, drawn north in pursuit of the oil-rich bowhead whale, were the first to record encounters with the Inupiat of Arctic Alaska, starting in 1848. Contact with the Natives followed the disastrous pattern established all over Alaska: new diseases that killed many, alcohol abuse that disrupted village life, and famine that followed overhunting of the whales and walrus. While the Inupiat had taken about one hundred whales per year, in 1850 alone the Yankees killed 17,000.

The U.S. purchase of Alaska was a fitting anticlimax to the Russian era, closer in character to a garage-sale bargain than the conquest of a resource-rich subcontinent. Russian control of Alaska, always weak, had grown untenable by the middle of the nineteenth century, and the Russians had located more easily exploited sources of fur. In March 1867, Secretary of State William Seward negotiated with the Russian ambassador in Washington, D.C., for the purchase of Alaska, paying $7.2 million, or about two cents an acre. Although the U.S. Senate approved Seward's treaty, Congress was reluctant

to appropriate the payment. The deal was mocked as "Seward's Ice Box": there was no general conception yet of Alaska's size or natural resources. The check was finally written in July 1868, but no government was created for the territory until 1884. Under the policy that had existed in other frontier settlements, areas with fewer than 5,000 non-Indian residents were provided only with a military garrison to maintain authority over the indigenous people, not a fully functioning territorial government. The census in 1880 found only 430 non-Natives in all of Alaska.

The major discoveries of the period came with the help of Natives. Joe Juneau and Richard Harris made a great gold find in 1880 at a place that later became the capital city of Juneau only with the help of Chief Kowee, a Tlingit. When gold was found in the Fortymile River country in 1886, it was because the Han Indians, who had no use for it, told the prospectors where it was.[1] Expanding into the Bush, the Alaska Commercial Company relied on Natives to provide furs to its trading posts, and when John Muir discovered Glacier Bay in 1879, he was led there by a Native guide.

Muir's respect for Native people and interest in Alaska for more than the economic value of its resources made him an unusual explorer during the period. He found parallels between his own spiritual ideas about nature and the beliefs of Alaska Natives that he learned around the campfire. His writings about Alaska—he made five trips over twenty years—popularized its beauty.[2] In 1899 Muir joined an Alaska trip aboard a luxurious chartered steamer paid for by railroad magnate Edward H. Harriman.[3] The trip was similar to other tours of the era led by John D. Rockefeller, Henry Villard of the Northern Pacific Railroad, and various members of Congress, except that Harriman augmented the big-game

hunting and sightseeing activities with work by a top-notch team of naturalists, artists, and writers he brought along.[4] Their account of the voyage ran to fourteen volumes, and, along with earlier expeditions that brought back descriptions, artwork, and photographs of Alaska, helped educate the nation about the beauty and value of its northern frontier.[5] That awareness would ultimately help build a foundation for a national policy of conservation of Alaska lands.

BOOM AND BUST

Eighty years of development, spurred by the discovery of gold in the late 1880s and "black gold"— enough in 1957 to make statehood desirable and in 1968, at Prudhoe Bay, the largest oil field in North America—would ensue before conservation would become a dominant force in Alaskan politics. Prospectors had been scratching the north since the Alaska purchase and had found gold in Southeast Alaska and on the Kenai Peninsula. But the Klondike discovery in 1896 coincided with a critical debate over whether the dollar should remain on the gold standard. The U.S. government backed every dollar in circulation with gold—the two were directly interchangeable—but the economy had grown faster than the supply of gold since the last big find in the Lower 48 in 1875. Money had grown ever more scarce, driving down the price of goods. People hoarded gold, taking it out of circulation and creating government shortages. The deflationary pressure seemed to benefit creditors: if you owed money it would have to be repaid with currency that grew

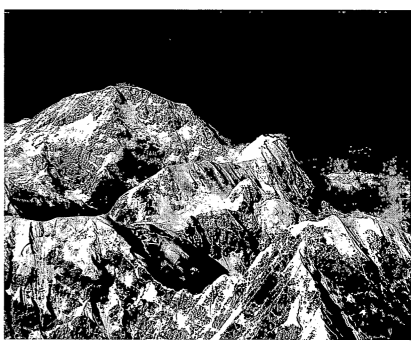

Pioneer mountaineer Bradford Washburn became the undisputed dean of Denali photographers through a lifetime of images of Mount McKinley, North America's highest peak.

ever more valuable. But wages and prices paid for farmers' crops kept falling, until in 1893, the economy collapsed and hundreds of banks failed because debtors were unable to pay back loans. The nation's worst depression to that point left 20 percent of workers unemployed and people literally starved. In 1896, William Jennings Bryant won the Democratic nomination for President proclaiming, "You shall not press down upon the brow of labor this crown of thorns; you shall not crucify mankind upon a cross of gold."[6]

That same summer, three men who were prospecting on a creek near the Throndiuck River— "Klondike," on the white men's tongues—walked into a local saloon and told of an incredible find. Within forty-eight hours, miners who for a decade had been working a strike a few miles away on the Fortymile River with only modest success had poled up the river to the Klondike and began digging

the creek gravel. The next spring, they washed that gravel through sluices, separated out the gold, and realized they were all rich men. In July 1897, sixty-eight prospectors steamed into the port of Seattle with gunny sacks and trunks full of gold—some two tons of it—and the Gold Rush began.[7]

For Alaska, the changes induced by the discovery of gold could not have been more sudden or dramatic. The Stampeders who set off, estimated at 60,000 to 100,000, were heading into a territory without roads or even towns, and populated by around 5,000 whites and 25,000 Natives. There were several routes to reach the gold fields, but the most direct departed from the head of the Inside Passage, which could be reached by steamer. Canadian authorities required Stampeders to pack in a year's worth of supplies, nearly 1,000 pounds to haul over the mountains—by horse on the White Pass and by Native stevedores on the Chilkoot Pass, which was too steep for horses. Once over the mountains, the challenges were water-based: across Lake Bennett on handmade boats and 500 miles down the treacherous Yukon River. In 1900 the White Pass and Yukon Route railway was completed, and large mining companies had bought out the Stampeders' claims and were running them as businesses.

By 1914, world gold supplies had doubled, but available gold increased much faster, as people who had hoarded theirs under mattresses threw it back into circulation. The U.S. economy shot forward.

A New Century

Groups began coming from outside the territory to record Alaska's natural beauty from the gold rush era on. The first of these parties had practical ends: government cartographers seeking to map the new U.S. purchase and survey teams sent by businessmen

to find resources and routes to get them out. Jack London, who had gathered material for his fiction as a prospector on the Klondike, published detailed and hugely popular adventure yarns about the North.

Attempts to climb Mount McKinley, North America's tallest peak, also drew national attention to Alaska. A long series of failed attempts culminated in the announcement that Dr. Frederick Cook had conquered the peak in 1906. When that claim was denounced as a fraud, a group of Alaskan prospectors mounted an ascent—only to find they'd climbed the shorter, north peak. McKinley's true summit was finally conquered in 1912, when Episcopal Archdeacon Hudson Stuck led a party of four to the top. Stuck's books about the mountain and his explorations of Alaska as a missionary helped feed the nation with a descriptive appreciation of the territory.

The period between World War I, which most historians use as a terminal date for the gold rush, to World War II, was a time of consolidation in Alaska. Population levels stabilized, as there was no economic boom to cause migration, but good fishing seasons and large-scale exploitation of mineral deposits helped create new towns and infrastructure that would expedite Alaska's later boom. In 1913, in his first inaugural address, President Woodrow Wilson called for the construction of a federal railroad, so that "Alaska, as a storehouse, should be unlocked." In 1923 President Warren Harding drove the golden spike at Nenana to complete the Alaska Railroad. The line started at the seaport of Seward, ran through a headquarters in the new town of Anchorage, and ended in Fairbanks. Although it was never a financial success, the railroad nurtured towns that the military would need when Alaska's strategic position became critical during World War II.

Another revolution in transportation leapfrogged the railroad almost as soon as it was completed. Roads were primitive at the time and still reach only a relatively small corner of the state, but aviation was uniquely suited to Alaska. The introduction of reliable small planes in the 1920s began to make the territory's great distances more manageable; even today flying is often the only practical way to get to most of its tiny widely scattered communities. In the age of aviation, the geographic remoteness that had made Alaska a forgotten corner of the world became its greatest strategic asset. Speaking to Congress in 1935, General Billy Mitchell predicted that Japan would likely invade Alaska: "I believe in the future he who holds Alaska will hold the world, and I think it is the most strategic place in the world."[8] In 1940, when Hitler seized the Netherlands, Congress approved building Fort Richardson in the railroad-created town of Anchorage, acknowledging Alaska's significance as a world aviation crossroads.

One difficulty for early explorers and conservationists of Alaska lay in the lack of maps of the area. Early efforts required diligent work. In 1936 *National Geographic* offered Bradford Washburn, a Boston photographer and climber, $1,000 to record the entire Alaska Range, including McKinley, with the new art of aerial photography. The resulting materials—maps derived from photographs— also allowed Washburn to pioneer a new style of mountain climbing in Alaska. Instead of using pack trains and many assistants to slowly approach and reconnoiter a mountain, he used aircraft and the information gained from his photographs to mount fast, lightweight ascents of Alaska peaks. In 1942 Washburn, then director of the Boston Museum of Science, led the first of his many climbs of McKinley to help the military test new Arctic gear—and to

capture the summit on film. Five years later he made another photographic expedition funded by RKO Radio Pictures. Pioneering new routes and photographing the mountain from thousands of angles, Washburn became the dean of McKinley climbers and photographers.[9]

Two other events made 1942 a watershed year for Alaska. Before the war, the defense of Alaska had been ignored; after Pearl Harbor was attacked, the government went into a crash program of construction all over the state. The largest project was the 1,522-mile Alaska-Canada Military Highway, or ALCAN, which created the first link between Alaska and North America's road system. Construction began early in 1942, traversing rugged unmapped wilderness from Dawson Creek, British Columbia, to Fairbanks, Alaska. Heralded as a near-impossible engineering feat, the highway was completed in eight months and twelve days by a force of 10,000 soldiers.

On June 3, 1942, General Mitchell's prediction came true: Japanese planes attacked the naval base at Unalaska's Dutch Harbor in the Aleutian Archipelago. More than seventy Americans died, and each side lost about ten planes in aerial combat. A few days later, the Japanese landed on the outer islands of Kiska and Attu, the first time U.S. soil had been occupied by foreign troops since 1812. On May 11, 1943, the Americans landed on Attu and an eighteen-day battle ensued, the Pacific Theater's second worst, after Iwo Jima. Then Kiska was attacked by American planes and ships, but when troops landed on August 10, they found the Japanese gone. More than two weeks earlier, an eight-ship Japanese fleet had slipped in through the fog and taken every Japanese soldier to safety, without being detected.

The war brought an explosive economic expansion and new people to Alaska. A flood of homesteaders, many of them former GIs, traveled the

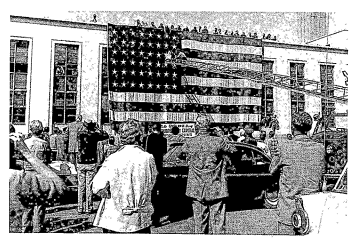

Alaska officially became the 49th state in 1959. A new star was symbolically added to the flag at the federal building in downtown Anchorage.

Alaska Highway, looking for the territory's wide-open opportunities. Military spending dropped sharply with the end of the war, but Alaska's strategic importance in the Cold War shortly brought another boom time. Because Alaska was the front line against potential Russian attack, the Pentagon built the world's largest airfield near Fairbanks, which housed America's nuclear-armed long-range bombers, and a radar line that crossed the state to give first alert of any bombers entering U.S. territory.

BLACK GOLD AND A FORTY-NINTH STAR
Before the war the population of Anchorage was a few thousand—even by Alaska standards it was a small town, with less than 6 percent of the total population. Cold War development brought a super-heated economy, extreme housing shortages, and pell-mell construction that made local fortunes. By 1950 the population had risen to 30,000, a quarter of all the people in the territory, and in the following eighteen months, it would grow another 50 percent.

The great political debate of the period—Alaska statehood—played out on the national stage from the beginning. Federal bureaucracy slowed development

projects. Statehood would provide Alaska with self-determination, a voice in Washington, a grant of land to develop as its citizens saw fit, and local management of fish and game resources. On the other side of the debate, many in Congress thought Alaska would be too expensive to govern, overwhelming local taxpayers and requiring a permanent federal subsidy.

The discovery of oil in 1957 was fundamental to the final approval of Alaska statehood. That Alaska had oil had been obvious since the turn of the century, when seeping crude was found at Katalla, near Cordova. In the late 1950s, a dozen companies were exploring the state when Atlantic Richfield made the first major discovery, on the Kenai Peninsula. Oil and gas discoveries followed in Cook Inlet. The finds were important locally, but more important, they apparently satisfied Congress that Alaska could have an economy to support itself. In 1958, Congress voted to make Alaska the forty-ninth state, providing a land grant of 104 million acres, so the new government would own the land needed to power a resource-based economy.

THE GRAND COMPROMISE
The growth of the national environmental movement spilled over to Alaska in the late 1960s and early 1970s. New migrants arrived who were interested in non-consumptive use of the outdoors—backpackers, photographers, and other recreationists. The Sierra Club, which John Muir had founded in 1892, set up an Alaska office, providing a strong voice for conservation on the local scene. The Alaska Center for the Environment, Alaska's first and most important home-grown environmental organization, started taking on land issues one at a time.

Native Alaskans, who for centuries had made a life from this land, and still lived partly by traditional hunting and gathering, had their own ideas about

how it should be conserved or used. The western concept of land ownership didn't fit their way of life, but Alaska Native leaders knew they had to act, or lose the land from which their culture grew. The Tlingit of Southeast Alaska had never conceded that newcomers had a right to Alaska. They sued for their land rights starting in the 1920s, claiming the entire region. The struggle for recognition of Native land rights grew from that point on.

Then, in January 1968, the discovery of North America's richest oil field on state-owned land at Prudhoe Bay forced land-ownership issues to be settled once and for all. To get the oil from northern Alaska to market would require a pipeline down the middle of the state, traversing land whose ownership had never been definitively resolved. Pro-development Alaskans, who, ironically, had always seen their manifest destiny in the wide-open frontier, suddenly had a stronger financial interest in resolving the conflicting land claims.[10]

Alaska Natives' land claims blanketed the state. Before the Johnson administration left office in December 1968, Secretary of the Interior Stuart Udall declared a freeze on all federal lands pending resolution of the Native claims, halting such land transfers as would be needed to build the pipeline. When Alaskan Wally Hickel (governor of the state from 1966–68 and 1990–94) took over Udall's office under President Nixon, he issued an order similar to Udall's to lift the freeze, but it was stopped by the Natives in federal court. In 1969 their litigation, begun more than sixty years earlier, yielded a ruling that validated their claims. Only Congress had the power to resolve the issue, but Democrats had been energized by the blooming environmental movement and opposed the pipeline project for fear of its effect on Alaska's ecology.

Until the Natives' claims were settled, the

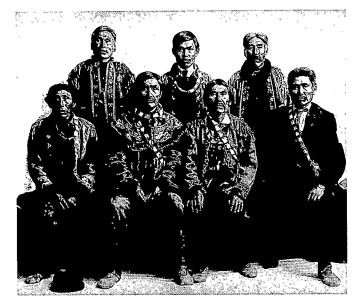

Athabascan village chiefs from the Tanana River region, near Fairbanks, at a meeting with a congressional leader in 1915. The issues of Native land claims they discussed would not be resolved for another fifty-six years.

Department of the Interior was legally barred from issuing a permit to build the oil pipeline. In the history of western civilization's treatment of indigenous people, it was a unique situation of power for those who before always had been brushed aside. When the courts upheld Udall's land freeze, that, remembers John Havelock, Alaska's attorney general from 1970 to 1973, "precipitated the state and the oil companies getting together and saying the only thing to do was settle the Natives' claims."[11] With the support of the oil industry, the Republican administration in Washington changed course. In 1971 President Richard Nixon got behind the Natives' cause and offered his own proposal to convey land and cash to settle the claims. Nixon met with Alaska Native leaders and offered to veto any land claims settlement they did not support.[12]

The settlement took the form of a grand compromise. For the state and the oil industry, Congress passed a law providing right-of-way to build the pipeline and clearing away all environ-

mental lawsuits and policy requirements. For the indigenous people, Congress gave 44 million acres of land and almost $1 billion, which was entrusted to newly formed corporations whose stockholders were all Alaska Natives. For the environmentalists, the Alaska Native Claims Settlement Act contained a special provision directing the Secretary of the Interior to prohibit the development or transfer of 80 million acres of Alaskan land for five years, and to consider this acreage for new national parks and conservation units. But despite how carefully the deal was crafted, when the pipeline right-of-way bill came to the floor of the U.S. Senate in 1971, the vote was an exact tie. Vice President Spiro Agnew cast the deciding vote in its favor.

The pipeline project shortly was underway and was completed in 1977, but the story wasn't over yet: that niggling little provision about 80 million acres for conservation remained to be settled. Pro-development Alaskans saw it as a lock-up of their chances for freewheeling resource development and resisted the creation of new conservation lands. Protracted haggling in Congress, including a filibuster by Alaska Senator Mike Gravel, prevented creation of the new national parks before the five-year deadline was up. President Jimmy Carter trumped the pro-development forces, using a 1906 law intended to protect antiquities to declare 56 million acres of Alaska national monuments, and the Interior Secretary issued an "emergency" order temporarily freezing another 50 million acres. But it was a stopgap solution, for by November 1980, when Ronald Reagan was elected president and the Republican party again became the majority in the Senate, there still was no solution. Senator Morris Udall of Arizona, Stuart's brother, offered a decisive solution. His bill—which became the Alaska National Interest Lands Conservation Act, known

as ANILCA—passed Congress in the waning, lame-duck days of the Democrats and was signed by Carter on his way out of office. A few months later development-activist James Watt became Secretary of the Interior, in control of all these lands, but by then it was too late—America's greatest single conservation law could not be reversed.

"Unquestionably, ANILCA is and was the single most significant piece of land conservation legislation ever enacted in the United States, and probably the world," says Deborah Williams, who as a legal intern at the Interior Department in 1980 was involved in writing ANILCA. "Overnight, it created more than 100 million acres of parks, refuges, and forests. And, just as a point of comparison, the state of California is 100 million acres."[13] Those acres total almost one-third of the state of Alaska, and there, ANILCA is the final law.

ANILCA marked the closing of the frontier. It delineated finally who owned what land in Alaska, ending a century of freewheeling exploration and development. While the course of Alaska's history since the 1898 gold rush had focused on human development of the wilderness, a conservation movement had grown in the rest of the country that placed value on keeping wilderness intact. In the late 1960s and 1970s, the conservation movement turned to Alaska as a last chance to make up for the nation's past mistakes. With a single act, more land for conservation was won in Alaska than had been preserved during the entire history of the conservation movement in the U.S. up to that point.

For many Alaskans and virtually all their leaders, however, the environmental groups calling for new national parks in the state were an outside enemy. Alaska's history, dominated by resource exploitation, taught that the value of wilderness lay in its economic potential. When the environmental movement hit its peak in the 1970s, these differing conceptions of how to value Alaska's immensity violently collided. For those Alaskans who saw it as a lock-up, a promise betrayed, it certainly was, at the very least, the end of an era. For conservationists, it was the crowning glory of the environmental movement, the closing chapter on a decade of change and victory. And, from any perspective, ANILCA was the product of an extraordinary and improbable ten-year-long story of daring and high-stakes political deals.

PRESERVING THE WILDERNESS

From atop a peak in Alaska's Brooks Range, cracked, weathered rock in endless, chaotic profusion fades into the horizon in every direction, a dizzying sea of unclimbed, unnamed peaks. This is the center of Gates of the Arctic National Park, an area of more than 8.5 million acres that is little visited: only those fully competent in outdoor survival skills and self-sufficient are encouraged to travel here as no facilities exist in the park. The range is the extension of the Rocky Mountains, a grand, ancient place that has never been ensnared in roads, towns, or even pioneer trails. Accessible only by small plane or on foot from a gravel road built during pipeline construction, its challenging climbs and treeless valleys are attempted only by serious outdoor adventurers and Alaska Natives who live nearby. And thanks to ANILCA, these lands will never be disturbed. The law's sweep is vast, on a scale with Alaska: not only Gates of the Arctic but also 100 million other acres, reaching from one side of the state to the other, are protected.

New parks created a focus for outdoors-oriented tourism all over the state. Before 1980 Alaska had only one national park, Denali, protecting Mount McKinley and some of the land around it. ANILCA doubled that park in size, and created nine more parks and preserves. It newly protected twenty-six Wild and Scenic Rivers, created nine new wildlife refuges, and expanded six. Lands within Tongass National Forest became national monuments, and millions of acres became national forest for the first time. Alaska now contains 69 percent of the National Park land in the U.S. and 85 percent of the National Wildlife Refuges. There are 3,152 miles of protected waterways on Wild and Scenic Rivers. In all, the federal government protects 152 million acres of Alaska in more than thirty conservation units, an area roughly the size of the state of Texas. Fewer than 1 million acres of the state—around one-third of one percent—are owned privately.[14]

On the border with Canada, Wrangell-St. Elias National Park, at 13.2 million acres, is the nation's largest park. Encompassing a region of massive, unclimbed mountains, it is more than six times the size of Yellowstone. Nine of the United States' sixteen highest peaks are here, at the intersection of four mountain ranges, rising vertically from the sea with an elevation gain greater than the Himalayas. A few thousand visitors make a rough, all-day drive on an abandoned railway line to see the abandoned Kennicott copper mine in the park and walk on a glacier, but the park is too vast and rugged to allow any but the most intrepid to enter far beyond this one route. So few have explored its backcountry, in fact, that one mountain guide made a business for decades of taking groups on ascents of peaks that have never before been conquered—and he's had plenty of peaks to choose from.

Alaska's most famous park, Denali, draws nearly half a million visitors annually. Partly because the park entrance was not connected to the highway system until 1972, here the National Park Service was able to avoid the mistakes that have turned so

English-born Sydney Laurence arrived in Alaska in 1904 and became its most prominent local painter, identified with the landmarks of its landscape through hundreds of images like this summer evening view of Mount McKinley, undated, from the collection of the late Hal Roach. Photo by Ed Ikuta.

many other national parks into parking lots. To get into the park proper, visitors have to leave their cars at the entrance and ride buses on a long, dusty road, vying for scarce seats through a reservation system. Once on that road, however, they experience an incredible wildlife safari, seeing bear, caribou, moose, and wolves behaving naturally, undisturbed by the traffic of too many tourist vehicles.

Katmai National Park, on the Alaska Peninsula of western Alaska, protects the area of the volcano Novarupta, whose 1912 explosion was the world's most violent in the past 3,000 years. Heard clearly in Juneau, more than 700 miles away, the explosion wiped out every living thing in forty square miles, yet the area was so remote that not a single person was harmed. A national monument protects the volcano's crater, the Valley of Ten Thousand Smokes, which continued steaming for decades after the eruption, but today is quiet. Only a wasteland of volcanic debris more than 700 feet deep remains, but the park's bigger attraction is a large congregation of brown bears, which comes between July and September to catch salmon jumping over a waterfall on their way up river to spawn. Visitors watch in comfort from wooden platforms at the lodge.

Kenai Fjords National Park, which encompasses the rugged, glacier-laden bays on the south side of the Kenai Peninsula, is accessed from the town of Seward, which thrives today on the tourism industry. Every day a fleet of tour boats heads across Resurrection Bay, each carrying hundreds—and sometimes thousands—of paying visitors on day trips to see the tidewater glaciers, sea otters, sea lions, humpback whales, and exotic seabirds that inhabit the fjords and islands of the park. Each tourist also supports the local economy by buying hotel rooms and meals, as well as the cost of travel to get to town.

Glacier Bay National Park, in Southeast Alaska, preserves a bay discovered by John Muir in 1879 when he paddled the Inside Passage in a canoe. When explorers passed a century earlier, they found a solid slab of ice instead of the sixty-mile-long fjord where cruise ships now travel in summer, its passengers hoping to spot whales and see the deep blue glaciers drop big bergs in the water. The ice melted so swiftly it created a new land, slowly redeveloping life and physically rebounding from the lost weight of glaciers by rising about an inch and a half per year. In 1925 President Calvin Coolidge protected a corner of the bay as a national monument, but with ANILCA, the entire bay became a park. Today, Glacier Bay receives some 500,000 visitors annually.

The rest of Alaska's national parks and preserves receive few visitors, but each possesses its own grandeur. Lake Clark National Park and Preserve, on the west side of Cook Inlet between Katmai and Kenai Fjords national parks, is a paradise for anglers who charter small planes to its remote lodges and many rarely used streams. Kobuk Valley National Park, protecting the beautiful Kobuk River in arctic Northwest Alaska, contains mysterious dunes of black sand as well as waters that attract river rafters for remote float trips. The Noatak National Preserve, just to the north, protects the slow-flowing Noatak River and its canyons, as well as the fish and game on which the local Inupiat subsist. (National preserves differ from national parks in that they may allow sport hunting. Subsistence hunting is permitted in some national parks in Alaska as well.) Also in Northwest Alaska, the Bering Land Bridge National Preserve, said to be the least-visited national park unit in the U.S., protects a swath of the northern Seward Peninsula where Asia and the Americas were connected during the last ice age. To the east, Yukon Charley Rivers National Preserve protects stretches of the rivers with a wealth of gold rush historic sites.

Alaska also has many national monuments and wildlife refuges that are not within national parks, including Misty Fjords National Monument, a wilderness within Tongass National Forest at the extreme southeastern tip of the state. Misty Fjords encompasses an extraordinary collection of granite fjords whose sheer cliff faces, some as high as those in California's Yosemite Valley, rise directly from the water. Accessible only by boat or float plane, and essentially without trails, the monument is a lonely wonderland for sea kayakers and anglers.

Admiralty Island National Monument, within the Tongass near Juneau, protects a rain forest habitat whose Tlingit Indian name, Kootznoowoo, means "Fortress of Bears"—and, in fact, a concentration of brown bears higher than anywhere else on earth lives here. Visitors travel in small groups to view the bears from platforms at Pack Creek, or explore the shoreline and lakes in canoes and kayaks.

Alaska's immense National Wildlife Refuges receive even fewer visitors, in part because they are intended primarily not for people to see but for animals to use. The refuges, managed by the U.S. Fish and Wildlife Service, include the Alaska Maritime National Wildlife Refuge, which protects dozens of island bird rookeries, the Kodiak National Wildlife Refuge, home to the huge Kodiak brown bear, and the Yukon Flats National Wildlife Refuge, a 19-million-acre region of wetlands used by migrating waterfowl. In total, 75 million acres of land are protected in sixteen refuges, most of which not many people have ever heard of, much less seen. Indeed, some virtually never receive a visitor, but all are protected forever, waiting to be discovered or remaining untouched, a reassurance when we feel that civilization has overtaken all the world.

The Continuing Battle

One place many people have heard of is the Arctic National Wildlife Refuge, a 19.3-million-acre area, about the size of South Carolina, in the northeast corner of Alaska. The refuge, set aside to protect the calving areas of more than 120,000 animals in the Porcupine Caribou herd, is a key prospect for Alaska's next big oil find. To the south, the refuge contains part of the Brooks Range and borders on lands belonging to Arctic Village, an Athabascan community that still derives sustenance and cultural continuity from the annual caribou migration. The

northern part of the refuge reaches to the Arctic Ocean, east of the Prudhoe Bay field, and may hold the same kinds of geological formations. For decades, the oil industry and pro-development Alaskans have asked Congress to open the refuge to oil exploration. Athabascans and environmentalists have said the caribou's calving grounds are too sensitive to allow industrial development and want the wilderness status that already protects 8 million acres from any mechanized activity to be extended to the rest of the refuge. Proponents of development are unwilling to cede the lands designated as 1002, because in article 1002 of ANILCA a decision on the management of oil and gas development on 1.5 million acres of the coastal plain was deferred. Government reports that weigh the cost and benefits of extracting this resource are based on the price of a barrel of oil: as that value has escalated, so has the tenor of the conflict.

Ironically, the drive to develop the refuge has made it only more popular with outdoor enthusiasts. Eco-tourism operators lead float trips down from the mountains on the beautiful and completely remote rivers of the refuge, the Sheenjek, Kongacut, Canning, and Hulahula. The popularity of the trips is owed in part to the publicity from the development debate and the travelers' urgency to see this unspoiled land before it's gone. Several of Alaska's largest eco-tourism wilderness companies were started in the midst of earlier development debates, formed by environmentalists whose specific goal was to bring people to Alaska's beautiful, remote areas and win converts for their side. So for some of the operators selling the trips, there's more to it than making money.

The fight goes on, but the biggest issues have been decided. Today, we know who owns Alaska: everyone does.

Notes

1. Elva Scott, interview by the author, September 1996. Scott, of the Eagle Historical Society, provided much of the information on Eagle and the Fortymile Country here and later in the essay.

2. John Muir, *Travels in Alaska* (1915; new ed., introduction by Edward Hoagland, New York: Modern Library Classics, 2002). Linnie Marsh Wolfe, *Son of the Wilderness: The Life of John Muir* (1945; reprint, Madison: University of Wisconsin Press, 1973).

3. Ken Chowder, "North to Alaska," *Smithsonian Magazine,* June 2003. In 2001, Thomas Litwin, an ecologist and professor at Smith College, along with twenty-four colleagues, followed the route of the 1899 expedition and edited their findings: *Harriman Alaska Expedition Retraced, A Century of Change* (Newark: Rutgers University Press, 2004).

4. Ernest Gruening, *The State of Alaska: A Definitive History of America's Northernmost Frontier* (New York: Random House, 1954).

5. The University of Washington maintains a website with a facsimile of the two-volume souvenir album produced by Harriman, which includes 254 of the 5,000 photographs made during the journey and a descriptive text by C. Hart Merriam, a member of the expedition who was one of the most popular nature writers of the era. http://content.lib.washington.edu/harrimanweb/index.html.

Kesler E. Woodward, *Painting in the North: Alaskan Art in the Anchorage Museum of History and Art* (Seattle: University of Washington Press, 1993).

6. Stan Jones, "Unlikely Savior," *Anchorage Daily News,* September 22, 1996. Jones's piece details the economic history of the gold rush.

7. The museums of the Klondike Gold Rush National Historical Park provided much of the information on the gold rush. The author and researcher also interviewed Karl Gurke, historical archaeologist for the National Park Service.

8. Claus-M. Naske and Herman E. Slotnick, *Alaska: A History of the 49th State,* 2nd ed. (Norman and London: University of Oklahoma Press, 1987).

9. Bradford Washburn and David Roberts, *Mount McKinley: The Conquest of Denali* (New York: Harry N. Abrams, 1991).

10. John Havelock was Alaska's attorney general, 1970–73. Havelock's first-hand memories of these events derive from an interview by the author, June 1997.

11. Ibid.

12. Robert D. Arnold, *Alaska Native Land Claims* (Anchorage: Alaska Native Foundation, 1978).

13. Deborah Williams was the Interior Department's top political official in Alaska when she was interviewed by the author in June 1997.

14. Statistics about the parks and conservation lands are drawn from memos provided by the U.S. Department of the Interior, and from park interpretive materials.

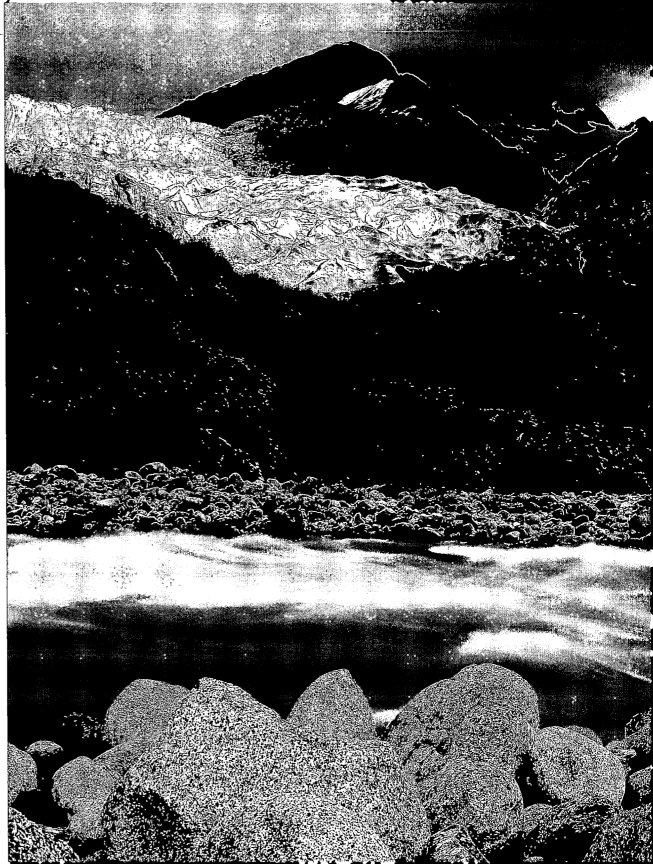

*Nevertheless, this is not easy country
you are about to wander through. It is
huge. Forty-four hundred square miles.
There are giant waves, avalanches,
thundering glaciers, savage streams,
violent winds, monumental rains, and
earthquakes. It is a land still emerg-
ing from the Little Ice Age. New-born
land, where there actually are small,
dainty things to look at but where the
mood is essentially somber, bold, austere,
brooding. It is harsh land, where errors
in judgment are rarely forgiven. But
as always, harsh land can yield great
rewards in many ways, after a time.*
—DAVID BOHN, *THE LAND AND THE SILENCE*
 (Sierra Club, 1967)

Herbert Glacier, Tongass
National Forest. Any view of
the thirteen wilderness areas
in Tongass National Forest is
likely to have been made by
a photographer arriving by
boat or plane because most
of this coastal rain forest
cannot be reached by road.

Aerial view of Kootznoowoo Inlet, Admiralty Is-
land National Monument, Tongass National Forest.
The Kootznoowoo wilderness is so called for its
extraordinary bear population—Kootznoowoo is
Tlingit for "forest of bears."

Spruce rain forest, Barlett Cove, Glacier Bay National Park. The heavy rain and temperate climate of Southeast Alaska create a perfect environment for growing very big trees. Sitka spruce are protected within the borders of Glacier Bay National Park, but those trees that grow elsewhere in the Tongass National Forest are the main commercial species of the embattled Alaska logging industry.

Waterfall on Cross Bay Creek, Tongass National Forest, near Juneau

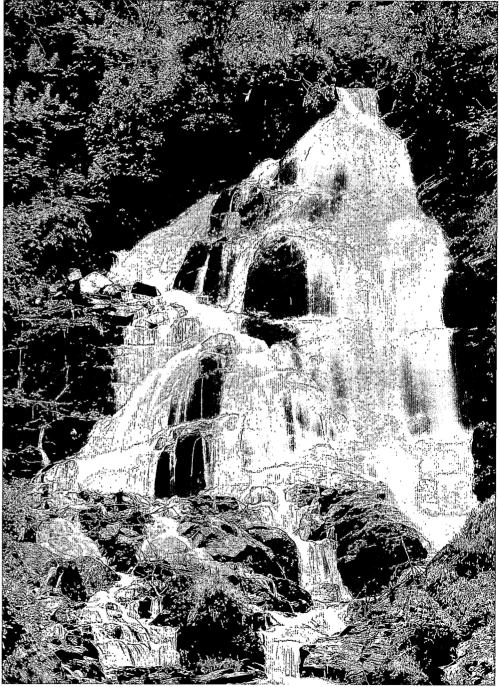

Kadashan Creek Pool, Chichagof Island, Tongass National Forest. Chichagof Island was John Muir's first stop on his way to finding Glacier Bay in 1879. Chichagof's Tlingit residents spoke in reverent terms of the nearby bay and glaciers they knew well.

Lamplugh Glacier, Johns Hopkins Inlet, Glacier Bay > National Park. Glacier Bay as it exists now has only been visible for two hundred years, its geography and wildlife revealed by the retreat of a huge Ice Age glacier sometime after 1794. Glaciers advance and retreat at such a fast rate that it is possible to witness dramatic disappearances or unveilings of land in a single lifetime.

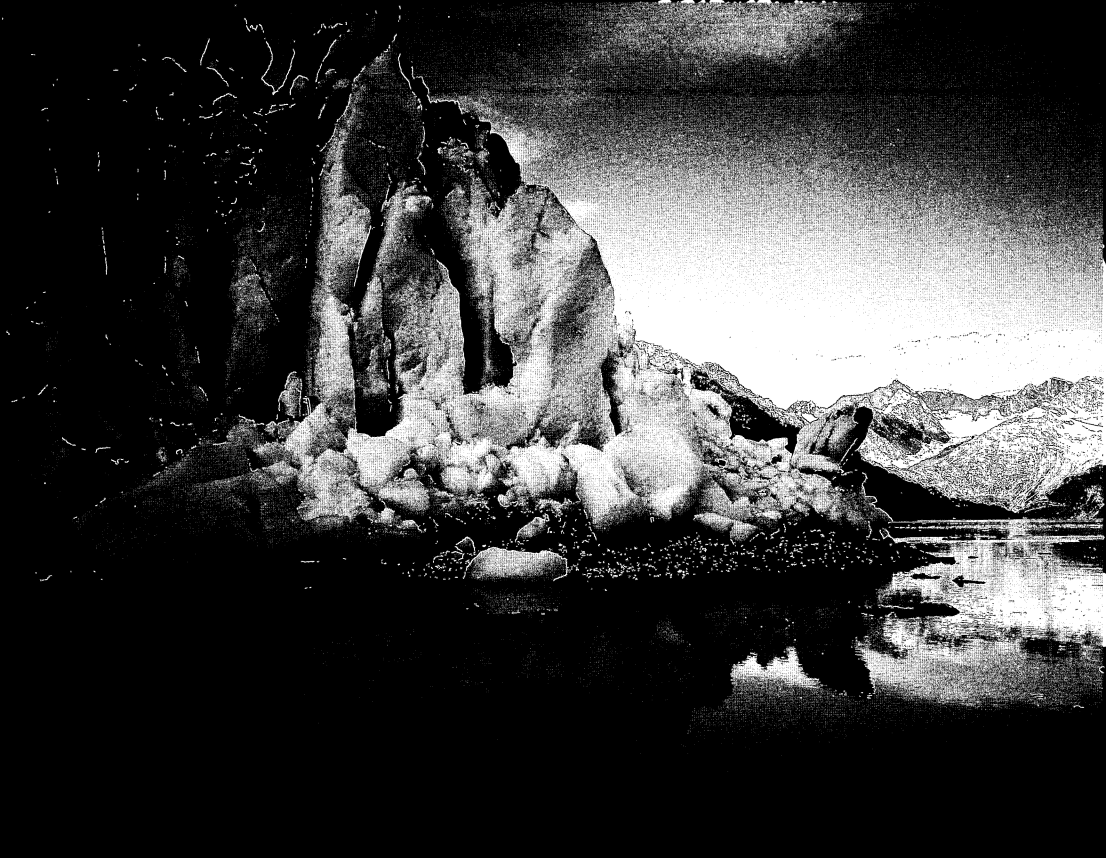

The next day found us in Glacier Bay on our way to Muir Glacier. Our course was up an arm of the sea, dotted with masses of floating ice, till in the distance we saw the great glacier itself. Its front looked gray and dim there twenty miles away, but in the background the mountains that feed it lifted up vast masses of snow in the afternoon sun.
—JOHN BURROUGHS, *ALASKA, THE HARRIMAN EXPEDITION, 1899 (Dover Publications, 1986)*

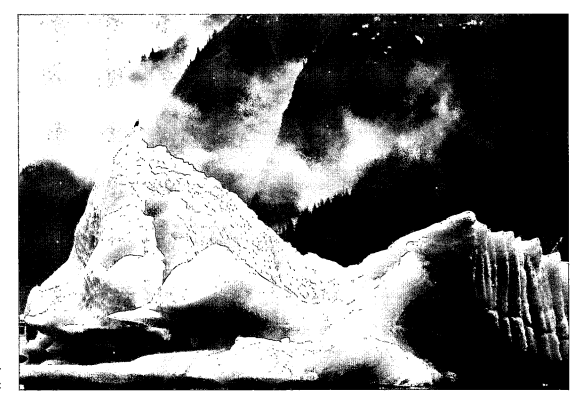

Bald eagle on iceberg floating in Tracy Arm, Tongass National Forest

Kayaker at tidewater face of McBride Glacier, Glacier Bay National Park

FAR RIGHT: Aerial view of Margerie Glacier, Tarr Inlet, Glacier Bay National Park. Glaciers are rivers of water in a solid rather than liquid state, formed by snow compacted so deeply that it turns into ice. When the ice reaches the ocean or warmer terrain, the melt, or "calving," of icebergs at the front edge of the glacier reaches an equilibrium with the snow being added at the top. Too much snow and the glacier advances; too little, and it retreats.

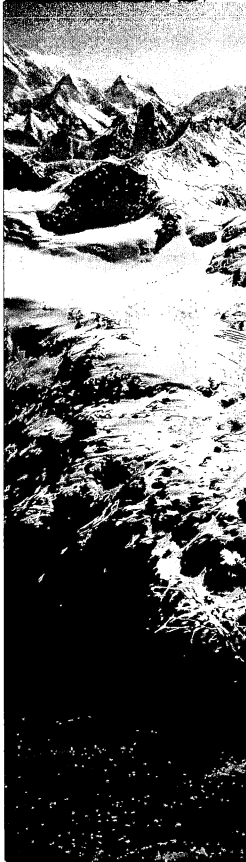

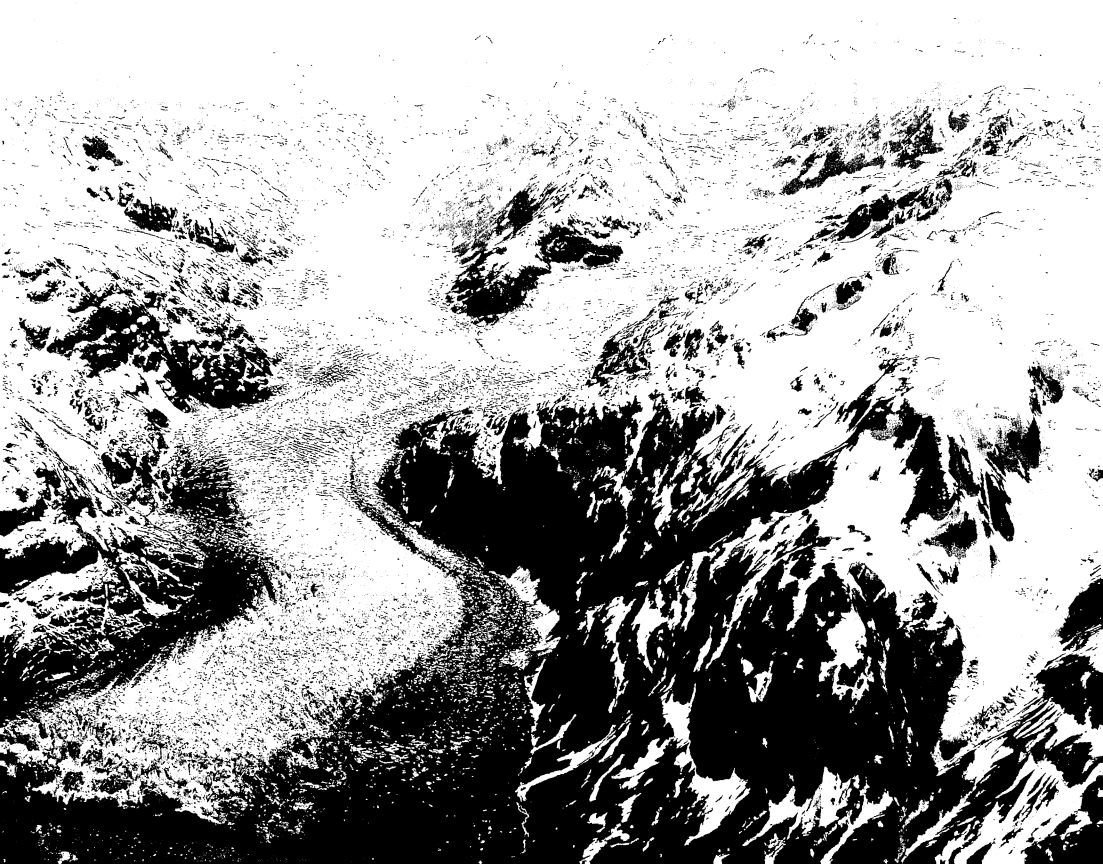

What is that roar or explosion that salutes our ears before our anchor has found bottom? It is the downpour of an enormous mass of ice from the glacier's front, making it for the moment as active as Niagara. Other and still other down-pours follow at intervals of a few minutes, with deep explosive sounds and the rising up of great clouds of spray, and we quickly realize that here is indeed a new kind of Niagara, a cataract the like of which we have not before seen, a mighty congealed river that discharges into the bay intermittently in ice avalanches that shoot down its own precipitous front. The mass of ice below the water line is vastly greater than that above, and when the upper portions fall away, enormous bergs are liberated and rise up from the bottom. They rise slowly and majestically, like huge mon-sters of the deep, lifting themselves up to a height of fifty or a hundred feet, the water pouring over them in white sheets. Then they subside again and float away with a huge wave in front. Nothing we had read or heard had prepared us for the color of the ice, especially of the newly exposed parts and of the bergs that rose from beneath the water—its deep, almost indigo blue. Huge bergs were floating about that suggested masses of blue vitriol.

—JOHN BURROUGHS, *ALASKA, THE HARRIMAN*
 EXPEDITION, 1899
 (Dover Publications, 1986)

TOP: Iceberg calving from the face of Margerie Glacier. The deafening sound of ice shards calving into water has been known to man for millennia. The Tlingit called it "white thunder."

Waterfall inside ice cave in Glacier Bay National Park

FAR RIGHT: Man explores glacier ice cave under Muir Remnant Glacier.

I have often thought of the forest as a living cathedral, but this might diminish what it truly is. When I worked as an anthropologist among the Koyukon Athabaskan Indians of interior Alaska, I encountered a different sense of the world's spiritual dimensions. If I have understood Koyukon teachings, the forest is not merely an expression or representation of sacredness, not a place to invoke the sacred: the forest is sacredness itself. Nature is not merely created by God: nature is God. Whoever moves within the forest can partake directly of sacredness, experience sacredness with his entire body, breathe sacredness and contain it within himself, drink the sacred water as a living communion, bury his feet in sacredness, touch the living branch and feel the sacredness, open his eyes and witness the burning beauty of sacredness. And when he cuts a tree from the forest, he participates in a sacred interchange that brings separate lives together.

—RICHARD NELSON, *THE FOREST OF EYES*
(University of Arizona Press, 1989)

Rain forest, Russell Fjord

It has been said that trees are imperfect men, and seem to bemoan their imprisonment rooted in the ground. But they never seem so to me. I never saw a discontented tree. They grip the ground as though they liked it, and though fast rooted they travel about as far as we do. They go wandering forth in all directions with every wind, going and coming like ourselves, traveling with us around the sun two million miles a day, and through space heaven knows how fast and far!

—JOHN MUIR, *JOHN OF THE MOUNTAINS: THE UNPUBLISHED JOURNAL*
(University of Wisconsin Press, 1979)

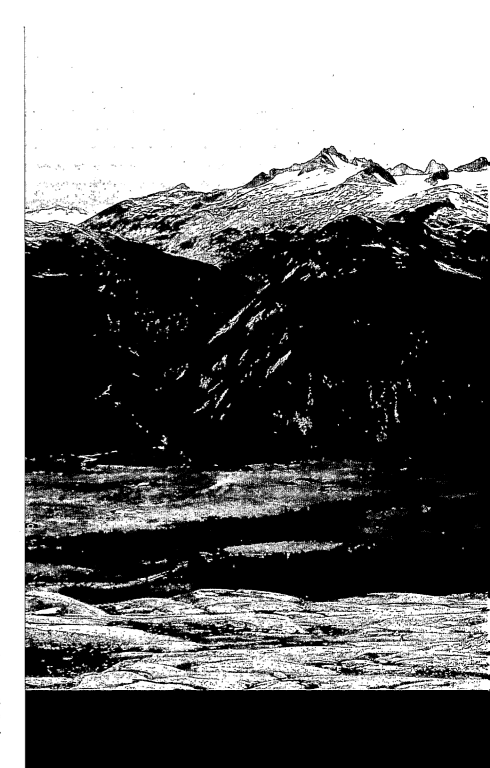

OVERLEAF: Four of the tidewater glaciers that surround the city of Juneau are seen in this Cirkut camera image, shot from the south side of the Taku River in 1984.

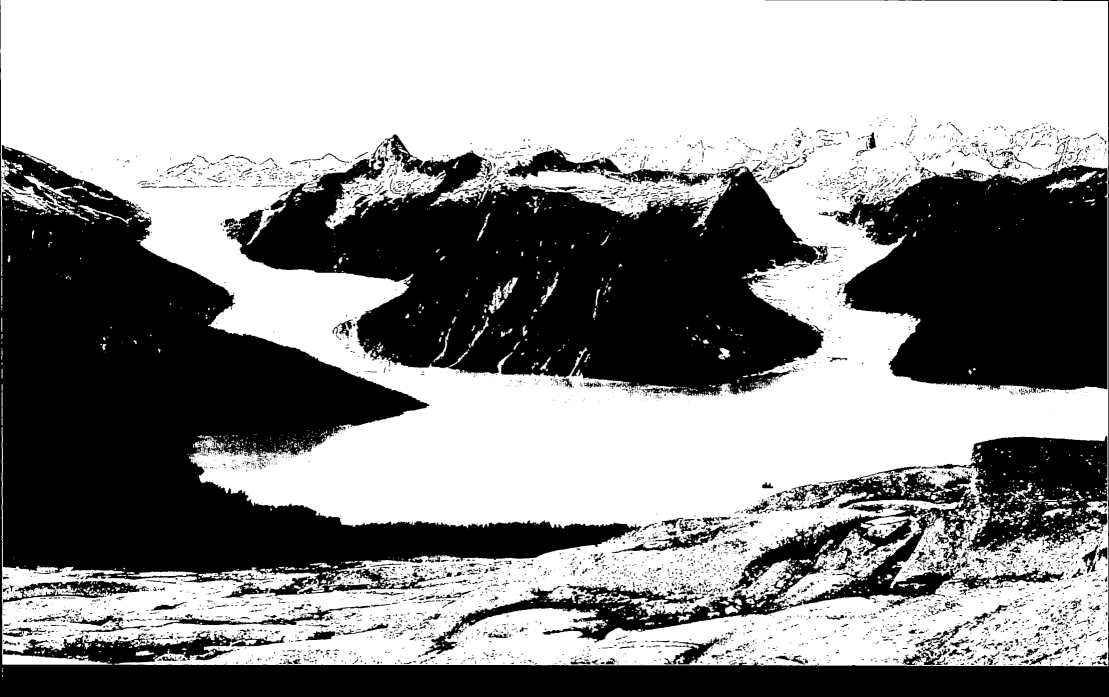

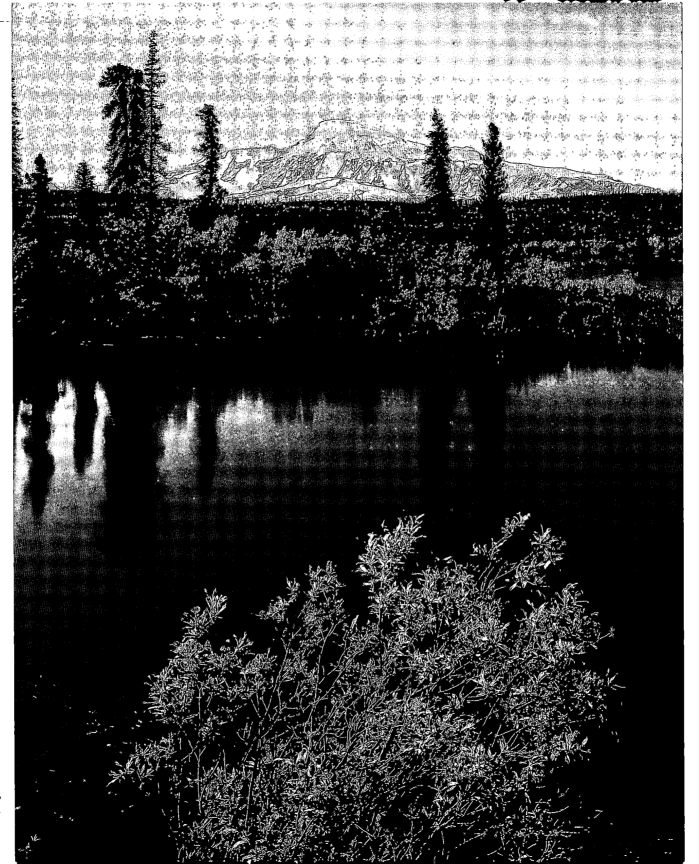

I am the land that listens,
I am the land that broods;
Steeped in eternal beauty,
Crystalline waters and woods.

—ROBERT SERVICE,
 THE COMPLETE POEMS OF ROBERT
 SERVICE (Dodd, Mead, 1945)

The Wrangell, St. Elias, Chugach, and Alaskan ranges converge in Wrangell-St. Elias National Park, which at 13.2 million acres is the nation's largest national park. Formed by volcanics and plate tectonics and shaped by glaciers, some of these mountains rise vertically with an elevation gain greater than that of the Himalayas.

Autumn pond with Mount Sanford,
Wrangell-St. Elias National Park

Mount St. Elias and range, >
Wrangell-St. Elias National Park

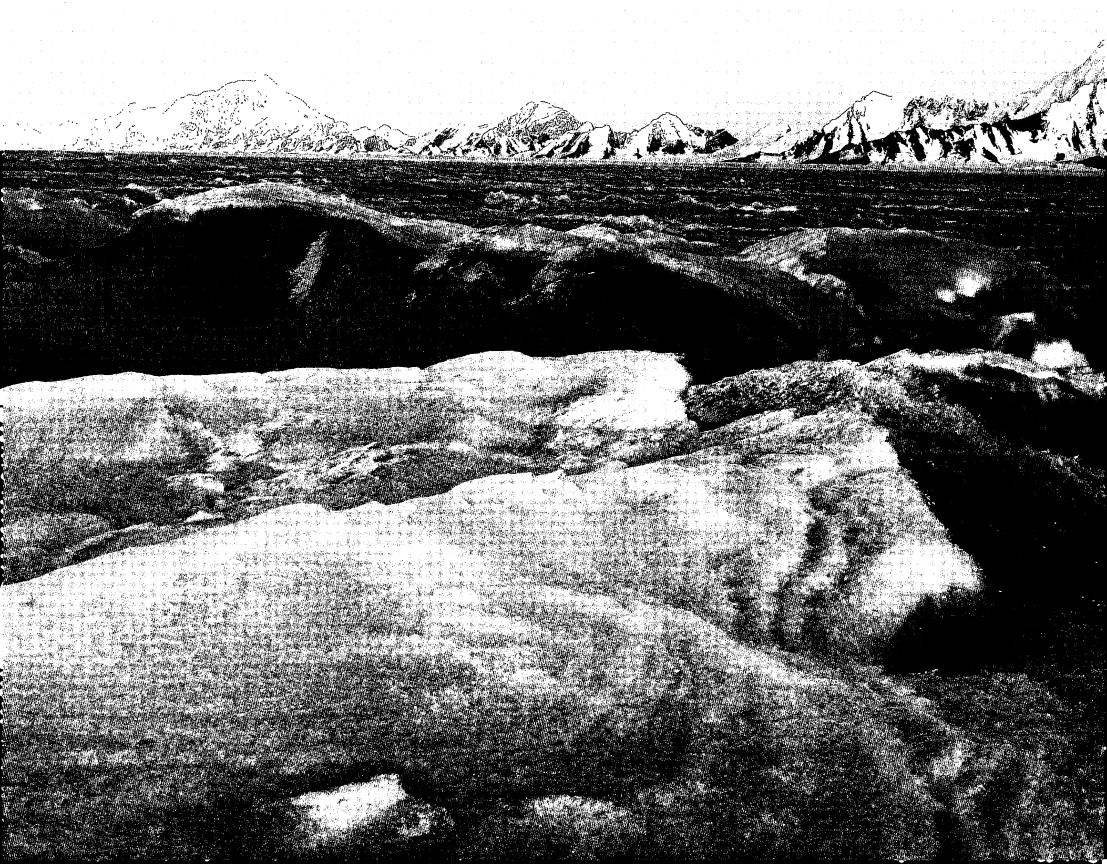

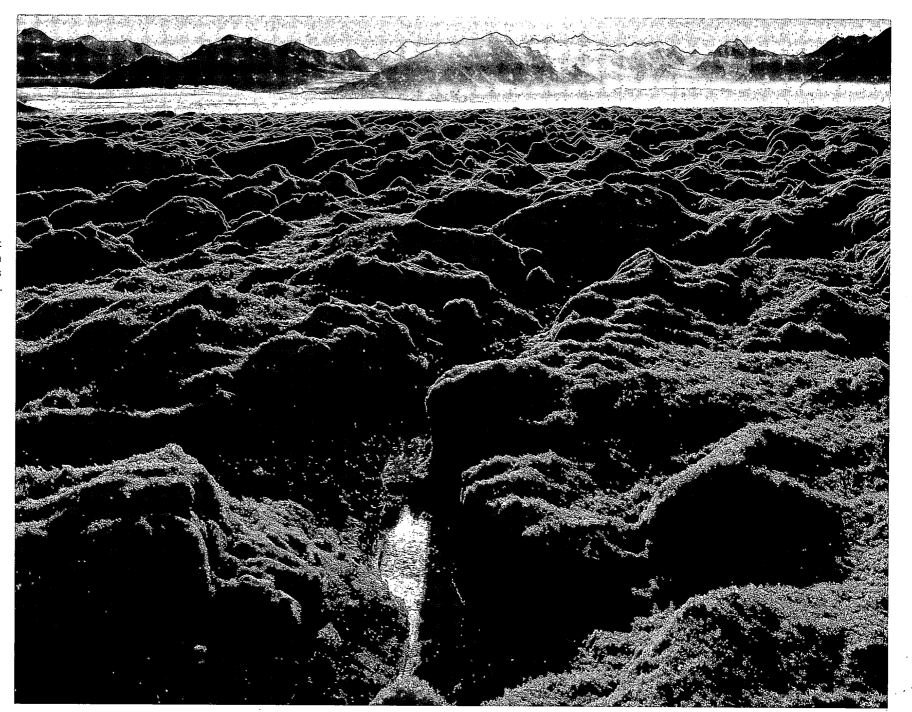

Wrangell Mountains at sunset. Midway Lake, Tetlin National Wildlife Refuge, is in the foreground.

< Jefferies Glacier, St. Elias Mountains, Wrangell-St. Elias National Park

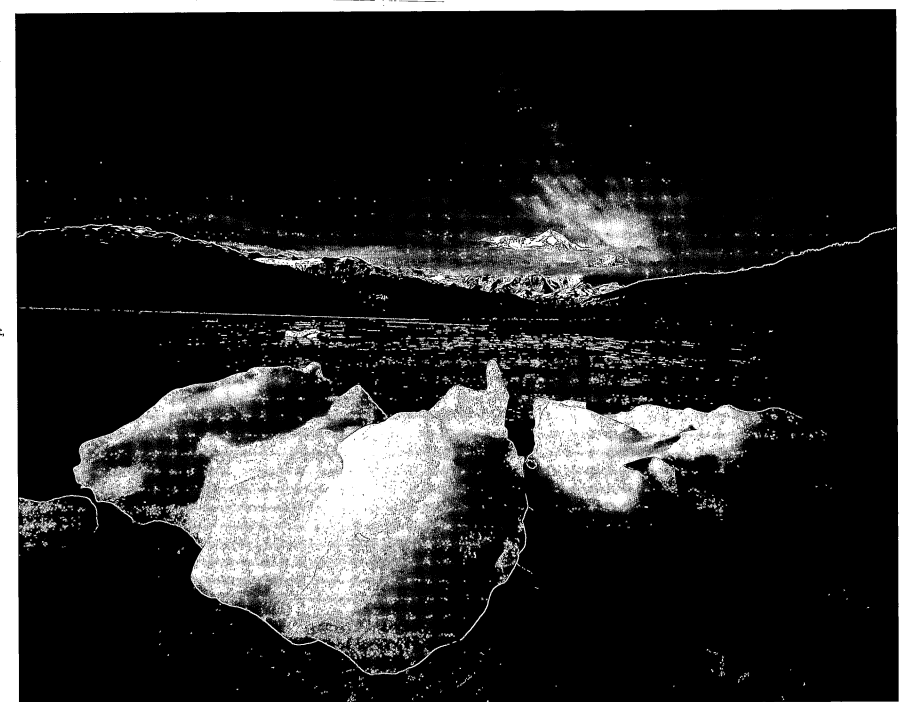

Mount St. Elias, at 18,008 feet, is Alaska's second-highest peak.

Footprints in the pristine snowfield reveal hikers on a promontory > overlooking the St. Elias Mountains. Snowfall in the upper St. Elias range can reach up to fifty feet in winter. Compacted snow feeds the park's seventy-five named and many more unnamed glaciers.

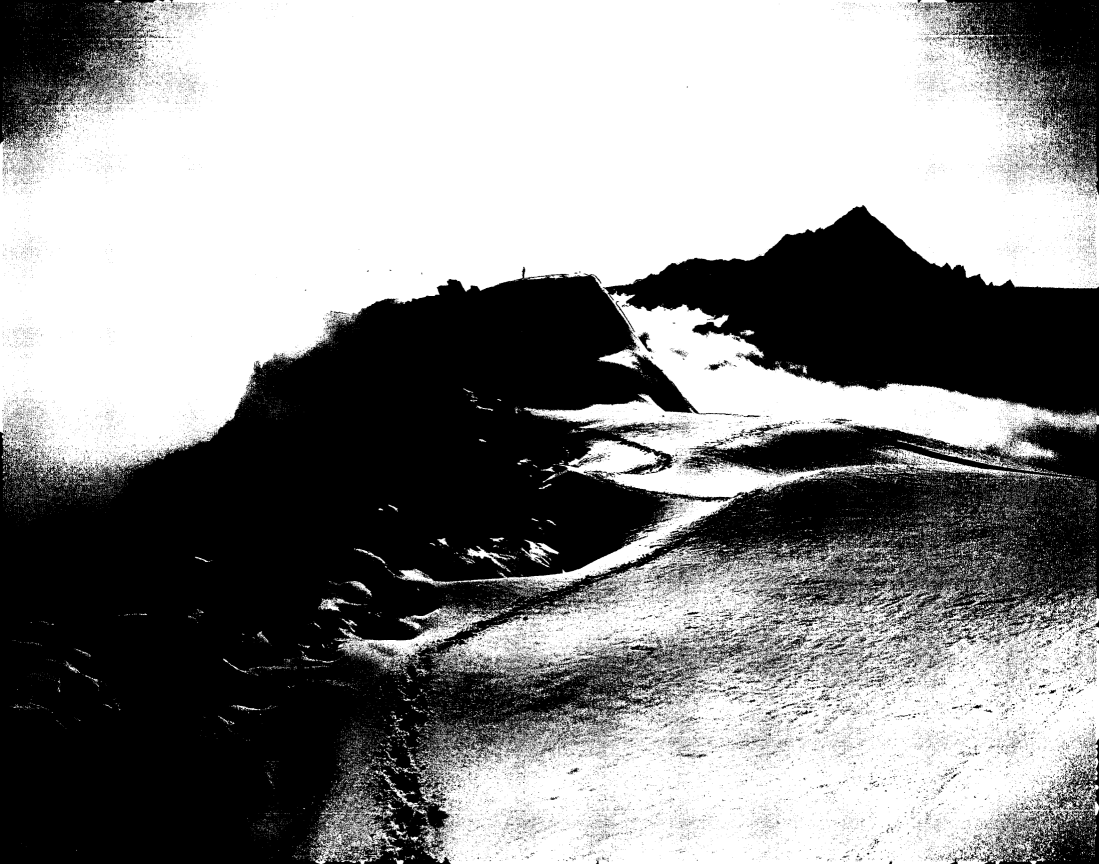

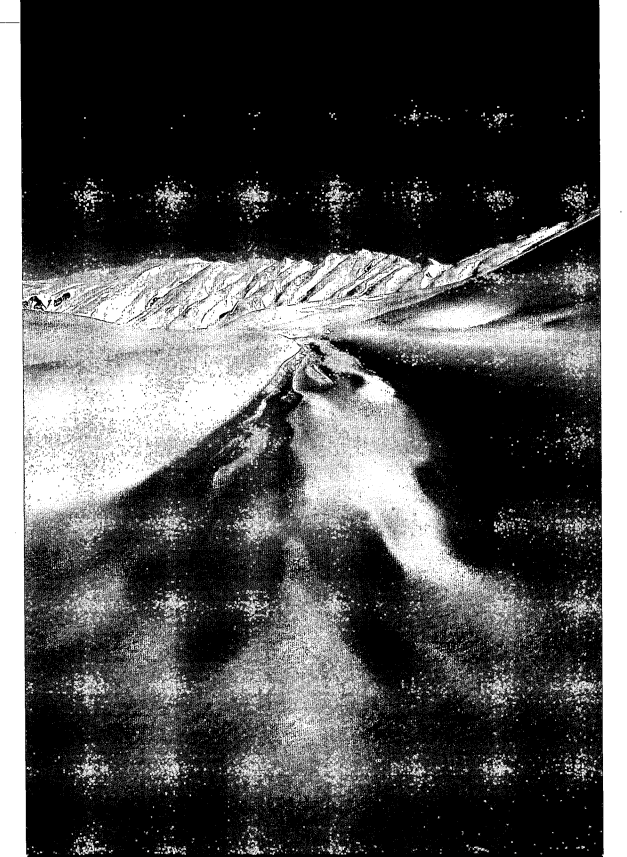

Meltwater pond on the surface of Malaspina Glacier, Chaix Hills, Wrangell-St. Elias National Park. Malaspina Glacier, at 3,937 square miles, the largest glacier in North America, is a piedmont glacier—that is, one that has emerged from mountain valleys and spread into adjacent plains.

Tundra, rolling land above > the timberline but below areas of permanent snow, supports no trees in its plant life but is rich in grasses, shrubs, mosses, lichens, and herbs.

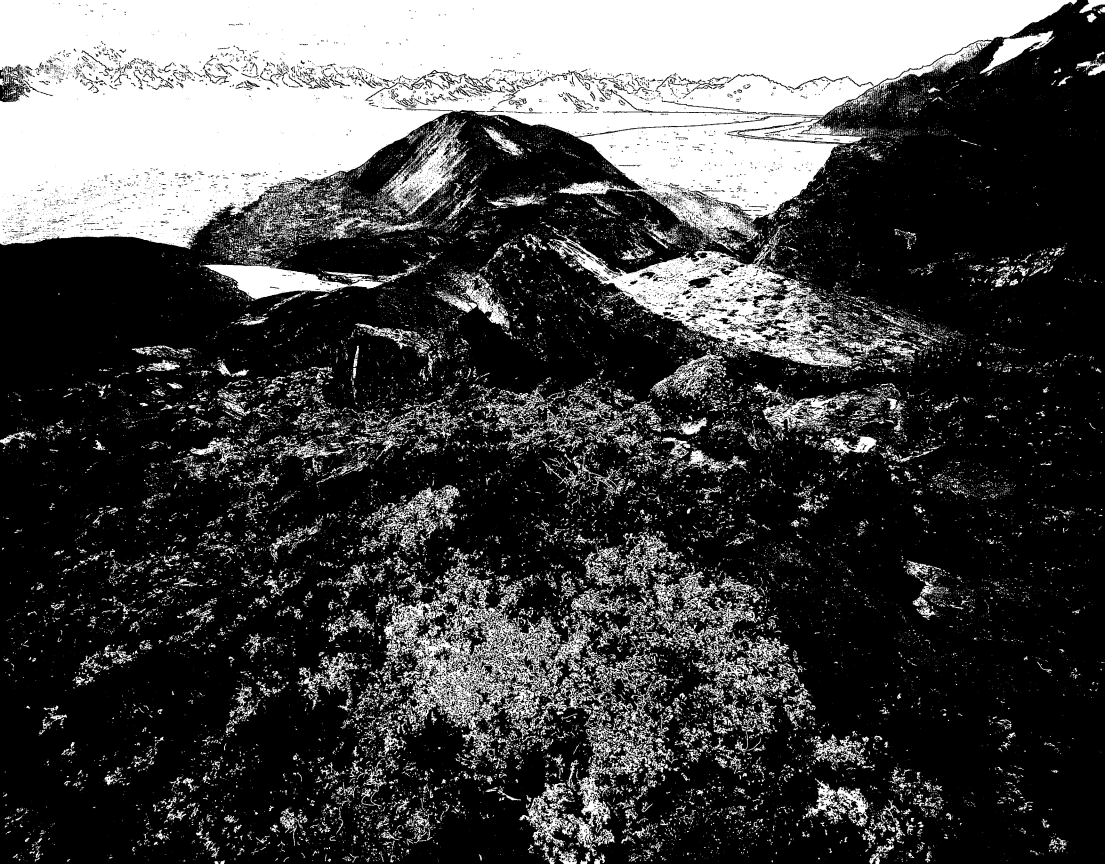

Aerial view of glacial water from Malaspina Glacier mixing with seawater

At the northern end of the Tongass National Forest, Yukatat Bay is fed by the enormous Hubbard and Malaspina Glaciers. The latter is named for the Italian explorer Alessandro Malaspina, who in 1791 was the first European to study Yukatat Bay.

Copper River, Wrangell Mountains, Wrangell-St. Elias > National Park. The Copper River flows alongside the ranges that make up Wrangell-St. Elias, carrying the gray silty melt of its glaciers to Cordova and the Gulf of Alaska. The Copper River, which still offers a rich supply of sport and subsistence salmon, was formerly the route of the railroad linking the Kennicott copper mines to the ocean 200 miles away.

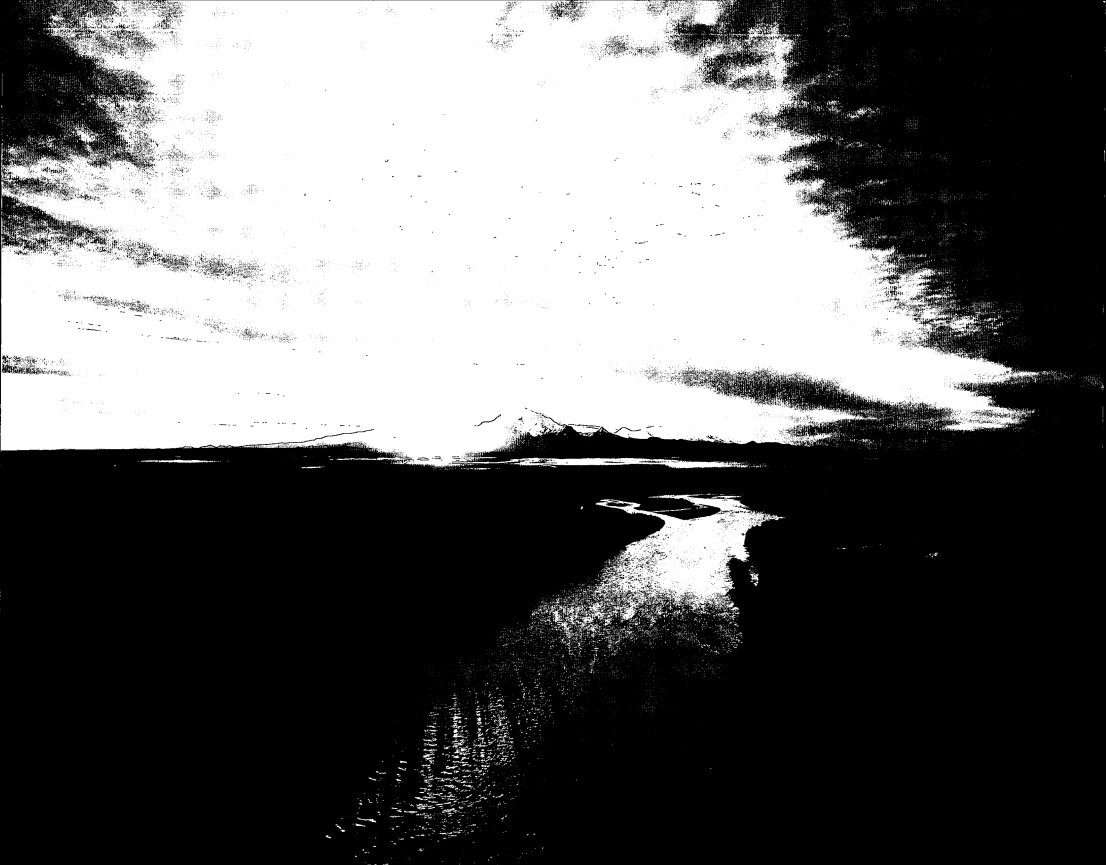

There is no single Eskimo word to represent "snow," for in the Arctic there is no such thing as just "snow." Instead there are terms for . . . "old granulated snow," "very old granulated snow next to the ground," "snow to be gathered for water," "snow spread out," "snow that is drifting," "snow like salt," "snow newly drifted," "snow piled up near the bottom of the hill," "snow mixed with water," "snow on clothes," "it snows," and so on. In all of these terms there seems to be no root word for "snow."

—BILLIE WRIGHT,
 FOUR SEASONS NORTH
 (Harper & Row, 1973)

Matanuska Glacier, in the Chugach Mountains, feeds the powerful Matanuska River. Strong downriver winds blow loess, or glacial silt, off the river's bars, which eventually settles in the Matanuska Valley, creating fertile farmland soil.

FAR RIGHT: Cow moose with calf crossing Glenn Highway through the Chugach Mountains

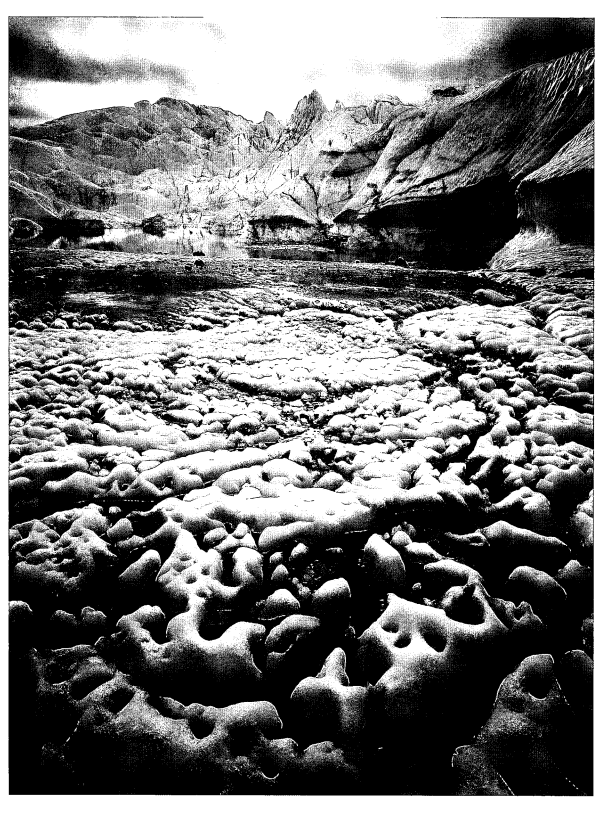

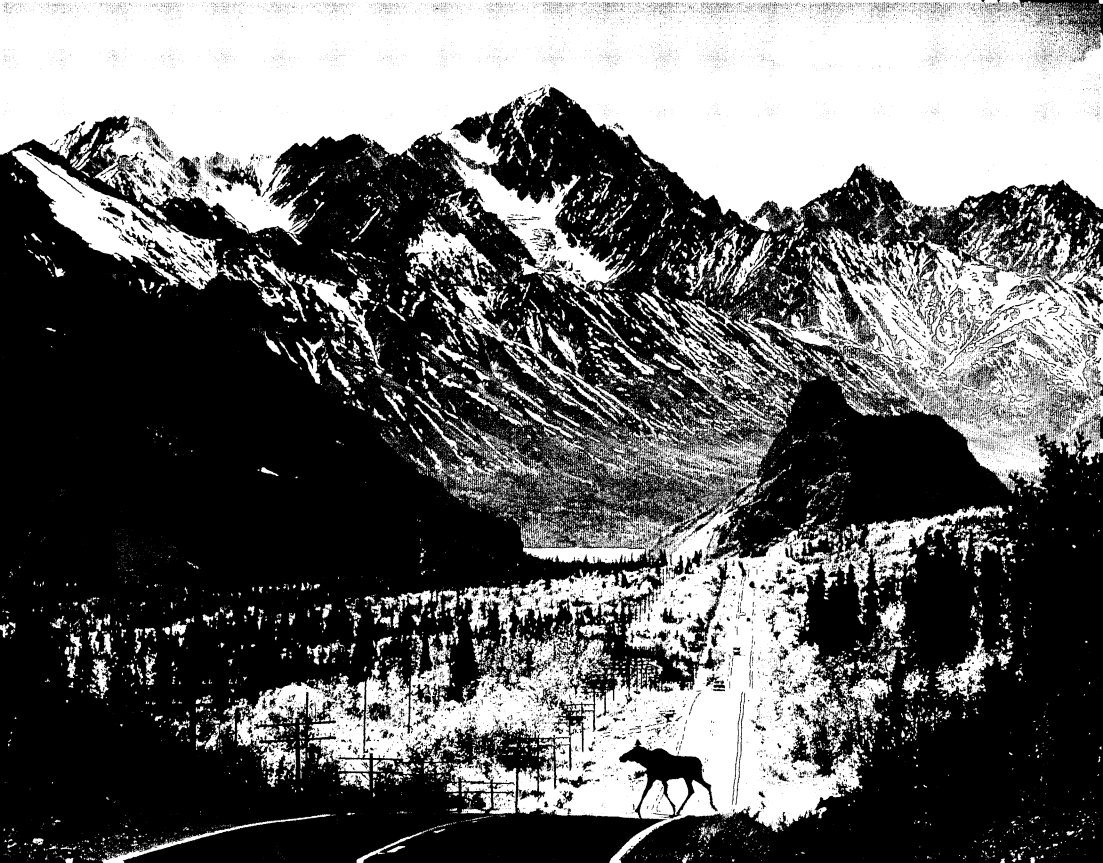

Three views of Thompson Pass, Chugach Mountains. Despite its remote beauty, Thompson Pass is reachable by automobile, and the Trans-Alaska pipeline crosses through it underground. Surrounding it are the 5,000-foot peaks of the Chugach Mountains.

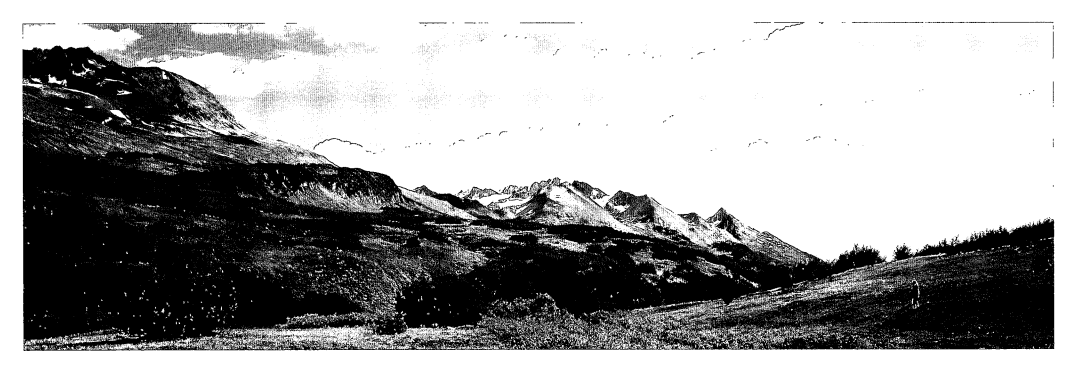

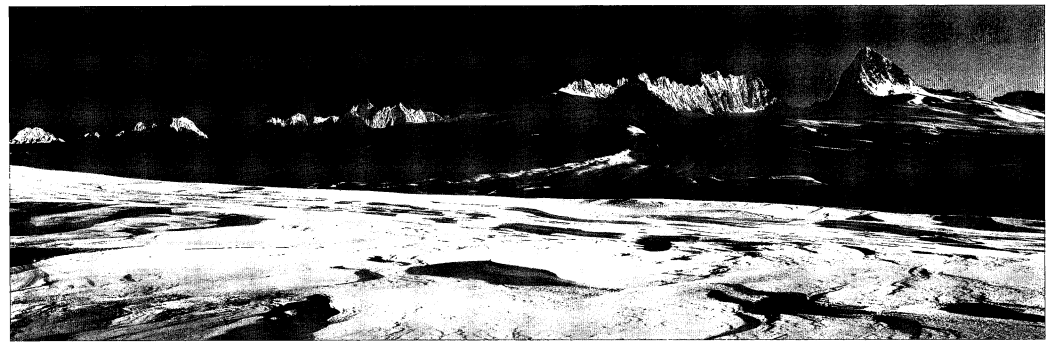

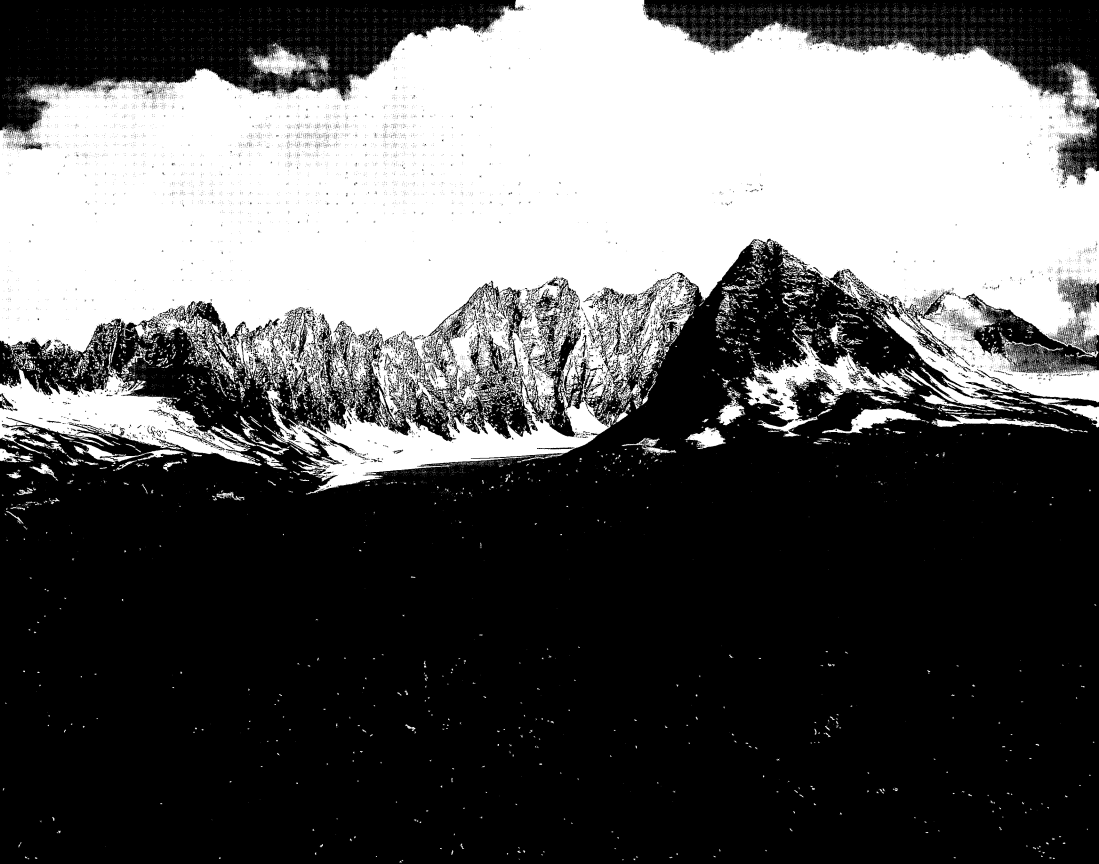

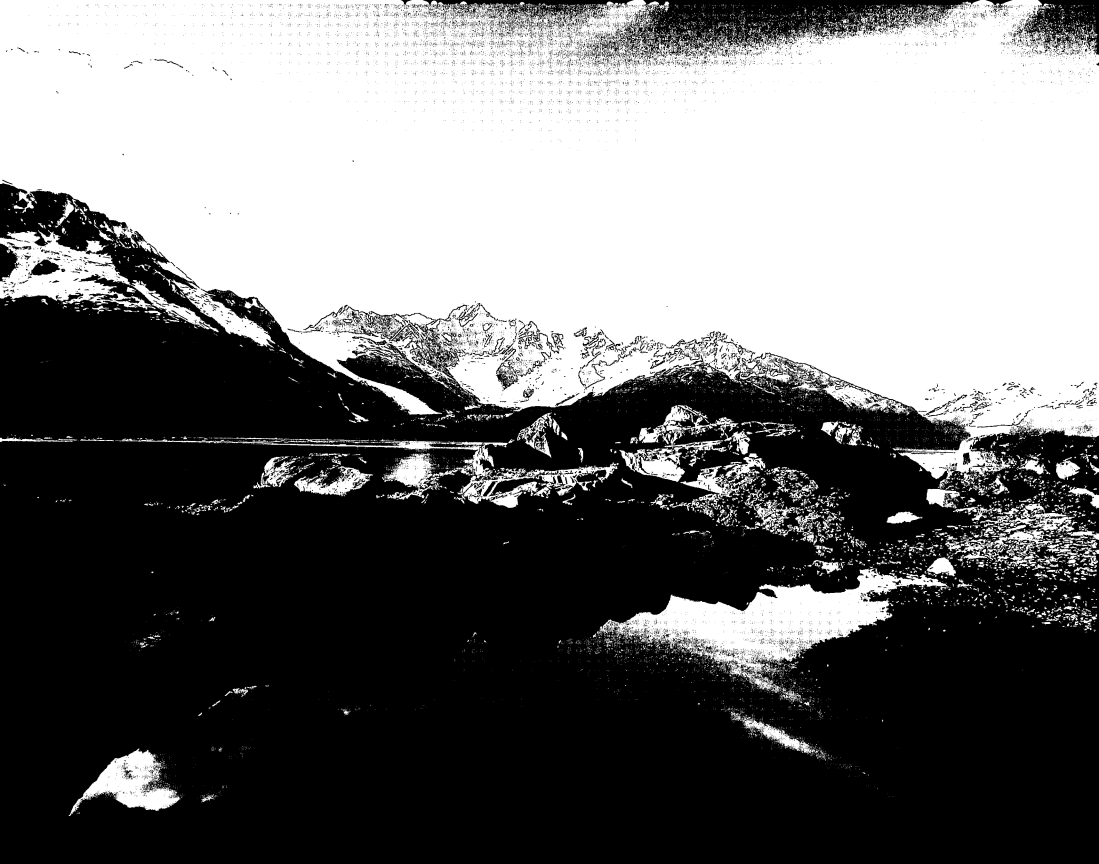

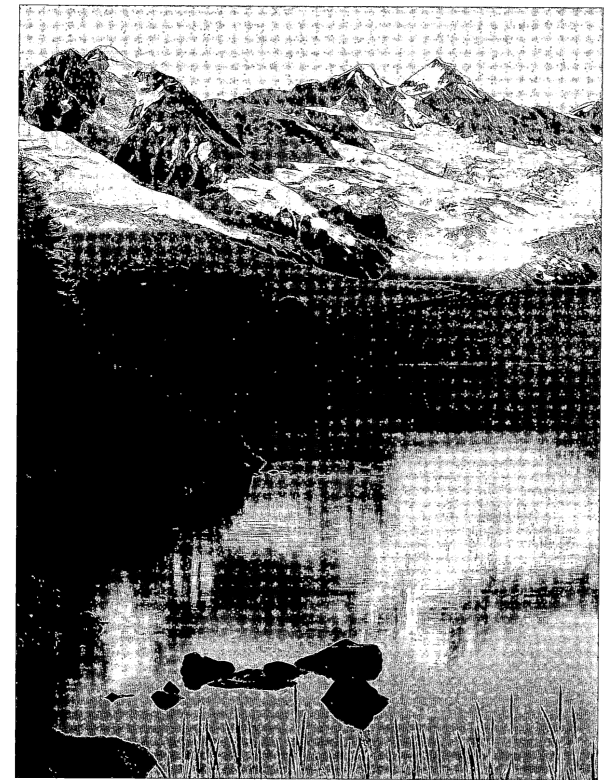

< A tidal pool in Harriman Fjord, Chugach National Forest

Photographer David Muench embarks in a kayak to explore Harriman Fjord in the Chugach National Forest.

Harriman Glacier reaches tidewater in the fjord of the same name, which commemorates the 1898 expedition along the Alaska coast led by Edward Harriman. Scientists, naturalists, painters, and the photographer Edward Curtis were invited to explore and record the little-studied coastal Alaska landscape on that landmark voyage.

It is an instructive example of a great glacier covering the hills and dales of a country that is not yet ready to be brought to the light of day—not only covering but creating a landscape with the features it is destined to have when, in the fullness of time, the fashioning ice-sheet shall be lifted by the sun, and the land become warm and fruitful.

—JOHN MUIR, *TRAVELS IN ALASKA (Houghton Mifflin, 1915)*

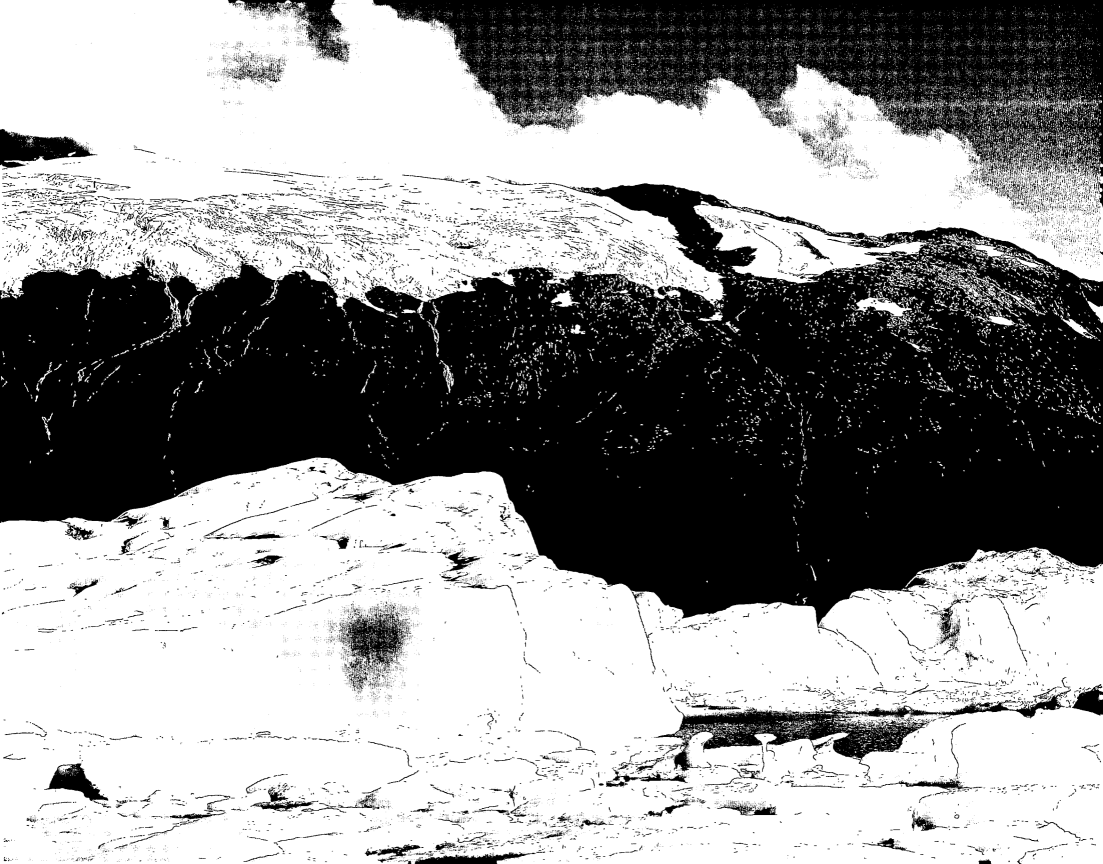

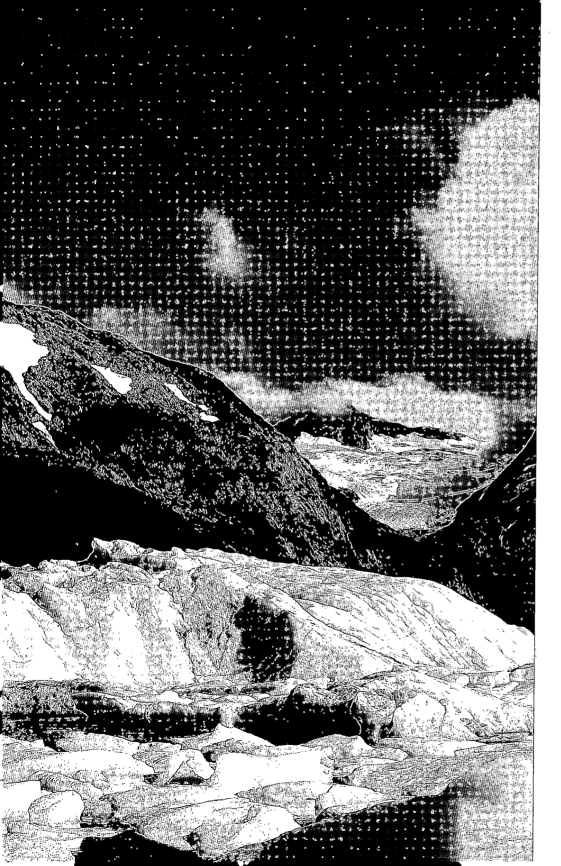

We are entering the Ice Age. Here glaciers still carve out the valleys. With your own eyes you can detect the piling up of moraines. The streams that gush, gray with rock flour, from under the ice, wind and wander over plains of broken stones. Some day they may dig themselves beds and become rivers. Now they are mere torrents that flood the land in the spring thaw. Water pours from sievelike cliffs. The grinding weight of the ice and the rush of thawed water toward the seas is fashioning these gorges. Escarpments stand up raw and new. Between snowfields, seamed and splintered by frost and storm, rock ridges strain toward the sky. It is a land in agonies of creation.

—JOHN DOS PASSOS, ENTERING THE ICE AGE (Holiday Travel, 1966)

Iceberg in Portage Lake, Chugach National Forest

OVERLEAF: Huge icebergs and the lake itself were created by melt from Portage Glacier.

The lake at Portage Glacier is an 800-foot-deep bowl of ice water. The glacier has largely melted, receding suddenly and unexpectedly from the lake in 1995, just ten years after a visitor center was built there. It had been expected to drop icebergs into the lake until 2010, but glaciers are predictably unpredictable.

FAR RIGHT: At its snout, Portage Glacier drops more bergs into the icy waters of the lake.

When we got close enough
we could hear

rivers inside the ice
heaving splits

the groaning of a ledge
about to

calve

—PEGGY SHUMAKER,

THE CIRCLE OF TOTEMS

(University of Pittsburgh, 1988)

Exit Glacier, barely thirteen miles from Seward, is one of the rare Alaska glaciers that can be climbed to reach the ice field that feeds it. (Exit Glacier gets its name for being an exit from the massive Harding Icefield above.) In summer, moose and sometimes bears can be seen from its walking trails.

OPPOSITE: Northwestern Arm, Kenai Fjords National Park, created in 1980 by the Alaska National Interest Lands Conservation Act, comprises 580,000 acres on the south coast and interior landmasses of the Kenai Peninsula. Its uninhabited, steep shoreline is the result of the peninsula's location at the convergence of the tectonic plates carrying the Pacific Ocean and Alaska landmass. Archaeological studies suggest there were once settlements along its deep fjords.

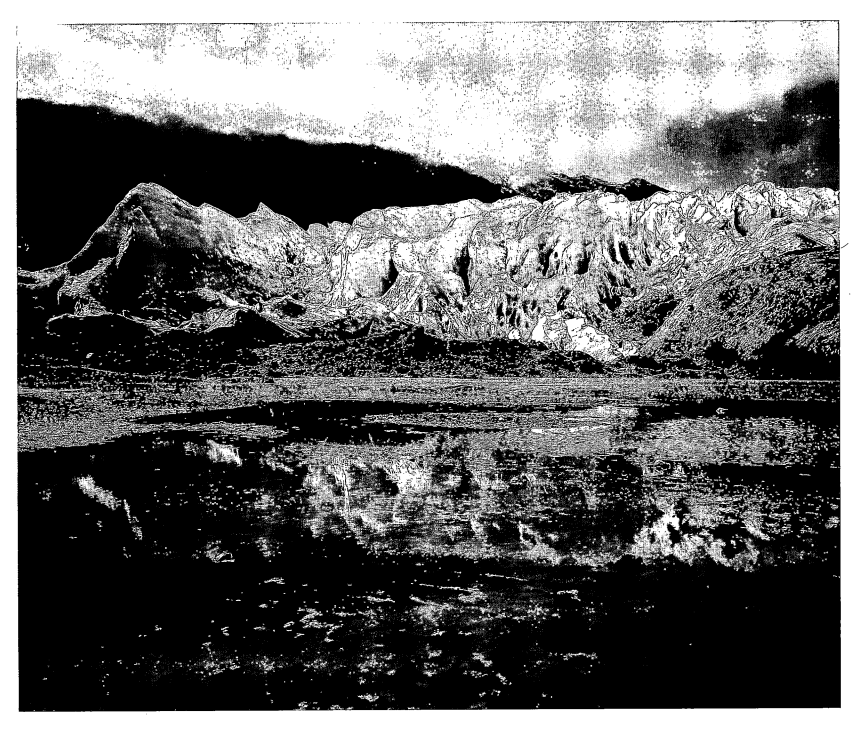

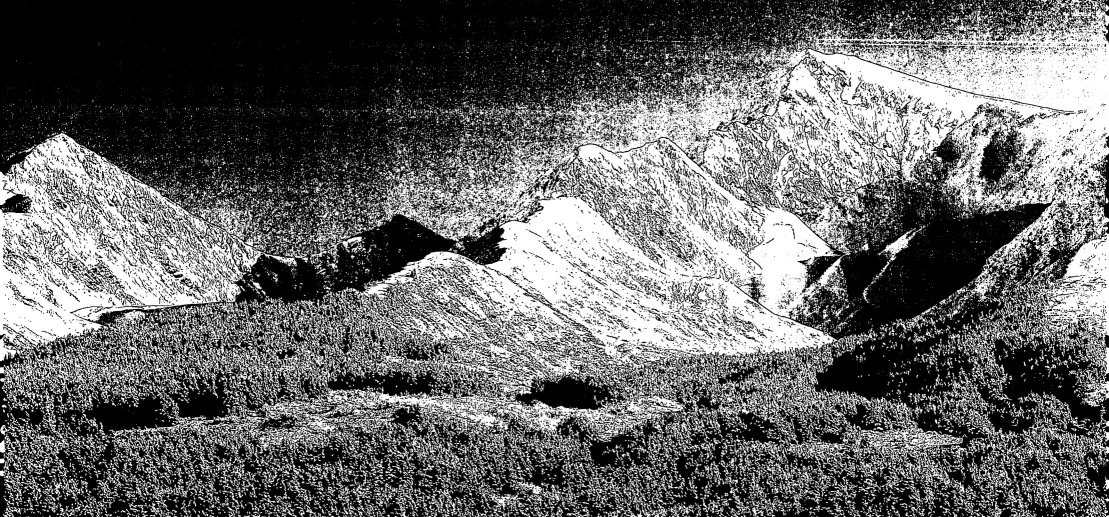

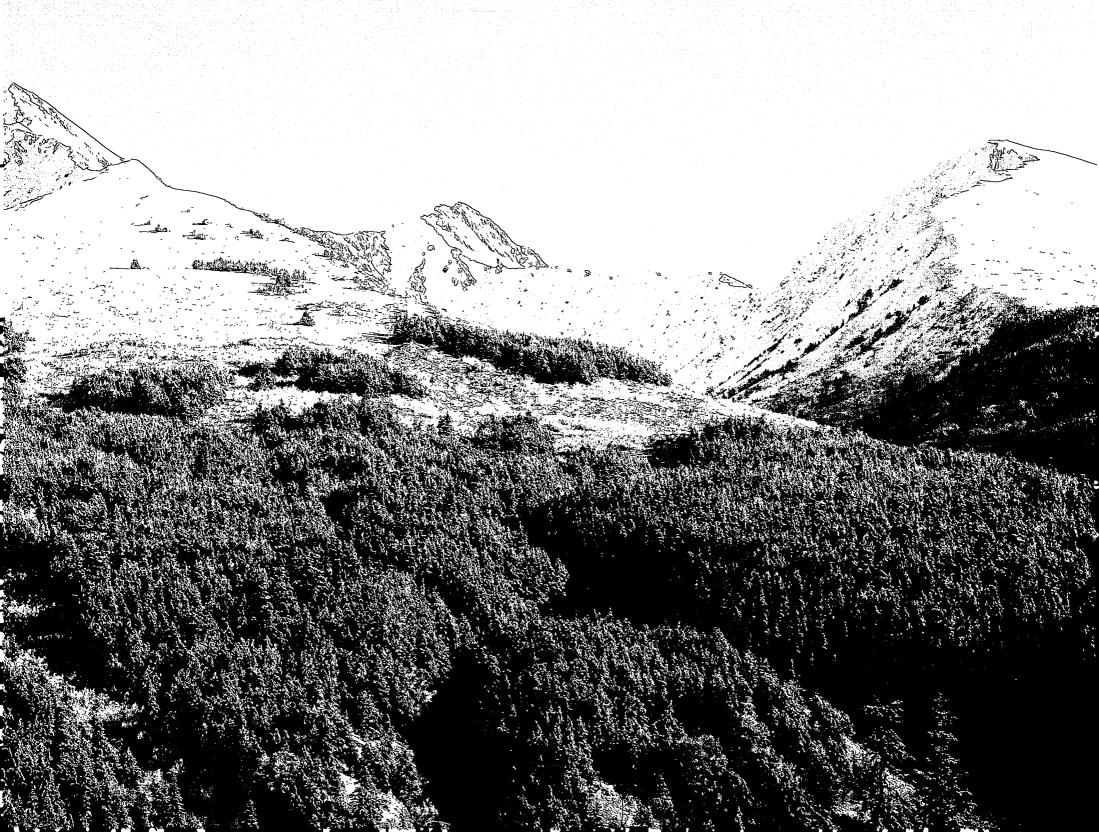

Of one thing we may be certain: Nature will cure everything, given sufficient time, and neither the earth nor the cosmos requires our presence to fulfill itself. One looks at the ceaseless activity of land, wind, and water, at the immense debris of the past, at the continued evidence of seasonal change and disruption, and observes how it all combines and re-forms, how species fail or adapt, return and pursue their fates, and he knows that the worst we can do will not be enough to destroy life, neither here nor anywhere else.

—John Haines, *Leaving Alaska*
 (Alaska, 1992)

Kenai Fjords National Park, 140 miles southwest of the site of the 1989 *Exxon Valdez* oil spill, was heavily affected by the disaster. The damage is no longer perceptible to visitors, and the area is still an exceptional location for sighting sea mammals and numerous species of waterfowl.

Previous spread: Because of violent plate tectonics, southern mountain ranges of the Kenai peninsula are being slowly sucked beneath the sea. On the northern side of the peninsula, the coast is rising in response. Alpine valleys are submerged and revealed by this enormous teeter-tottering landmass.

Top left: Sea lions bask on rocks as yet untouched by crude oil.

Bottom left: Three-hole rock in Aialik Bay, Kenai Fjords National Park, was carved by violent wave action. It is a popular destination for both tourist boats and nesting horned puffins.

Top right: Sea birds flock to the cliffs for safe nest sites.

Bottom right: Black-legged kittiwake rookery

Aialik Peninsula can be > seen beyond the terminus of Bear Glacier, which connects to the Harding Icefield in Kenai Fjords National Park.

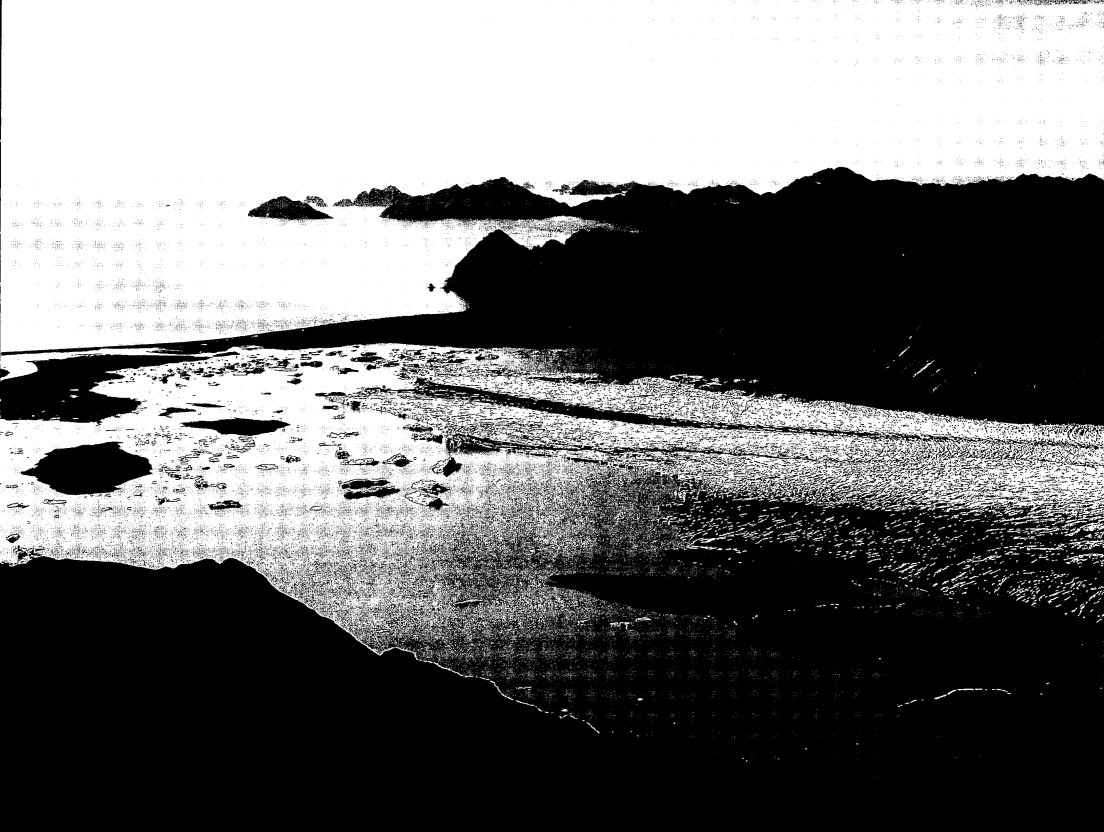

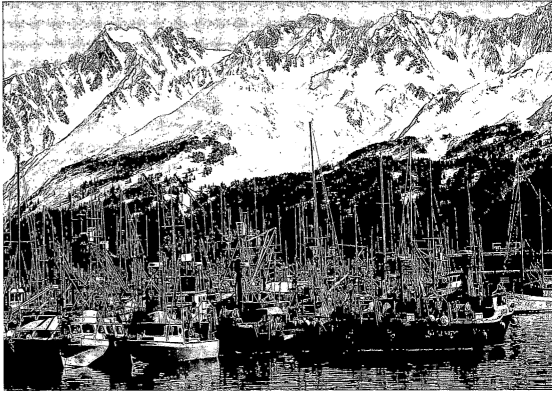

*Seward is fast going ahead: Dickinson Avenue is nearly
cleared and grubbed; will have Government Way and Caine
Avenue under way shortly; and surfacing Dickinson Avenue
will be done in the near future. Men are cutting piling for the
dock. The railway engineer corps and other men will be here
shortly and then Seward will be a lively camp. At the present
time, we number about forty and increasing right along, men
coming in from the interior. (There will not be any more help
needed until we get more supplies as we are almost out and
not enough to run us.) The first white child born in this section
was on February 8th to Mr. and Mrs. Kimball. Has not yet
been named. A girl.*

—*Dispatch sent to the* Valdez Prospector,
 April 18, 1903

ABOVE LEFT: Resurrection Bay, which is today dominated by the
town of Seward, was visited and named by Russian Governor
Alexander Baranov in 1793. Charter boats tour the area to
view the sea otters, sea lions, whales, puffins, cormorants,
mures, and various sea ducks that inhabit its waters.

ABOVE: Seward boat harbor with Chugach Mountains in the
background

There is one other asset of the territory not yet enumerated; imponderable and difficult to appraise, yet one of the chief assets of Alaska, if not the greatest. This is the scenery. There are glaciers, mountains, fiord and glacier scenery. For thousands of miles the coast is a continuous panorama. For one Yosemite of California, Alaska has hundreds. The mountains and glaciers of the Cascade Range are duplicated and a thousandfold exceeded in Alaska. The Alaska coast is to become the showplace of the entire earth, and pilgrims not only from the United States but from beyond the seas will throng in endless procession to see it. Its grandeur is more valuable than the gold or the fish, or the timber, for it will never be exhausted. This value, measured by direct returns in money received from tourists, will be enormous; measured by health and pleasure it will be incalculable.

—HENRY GANNETT, *ALASKA, THE HARRIMAN EXPEDITION, 1899 (Dover Publications, 1986)*

Ruth Glacier fills the Great Gorge below Mount McKinley in this aerial view of the Alaska Range in Denali National Park.

OVERLEAF: Wonder Lake, eighty-five miles into Denali National Park along its only road, is the closest one can get by automobile to Mount McKinley, twenty-seven miles away. At six million acres, roughly the size of Massachusetts, the park is amply sized for the moose, caribou, fox, sheep, bears, beavers, wolves, and dozens of other mammals who live there. They are mostly undisturbed, as the park's main road is closed to the public, and visitors, with few exceptions, may only enter the park by Park Service buses.

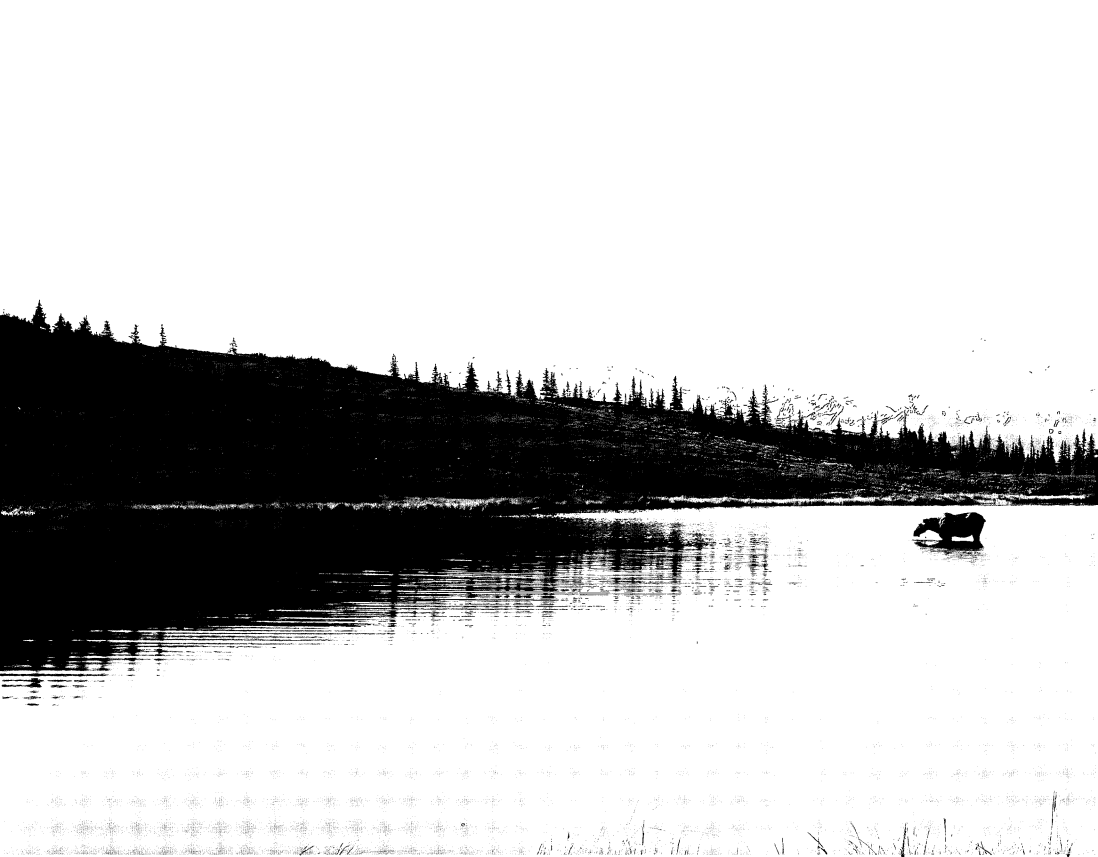

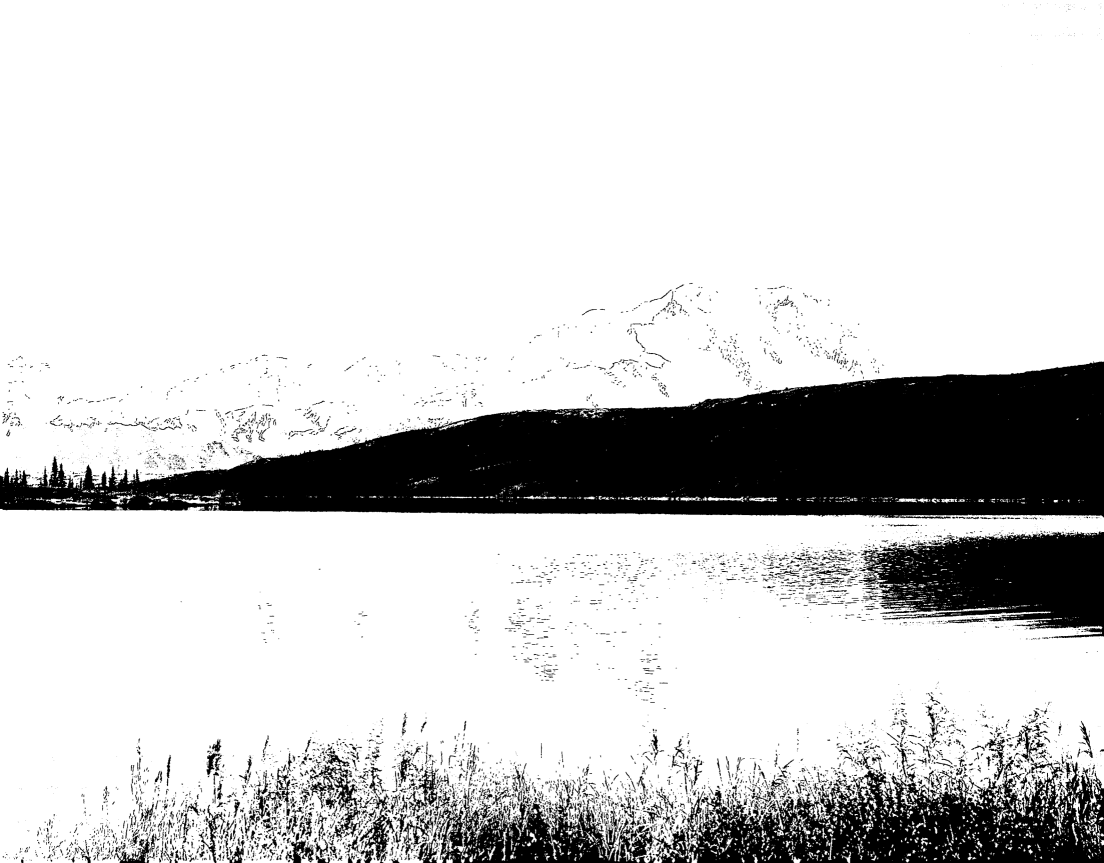

Thorofare area, Alaska Range

A pond near Wonder Lake displays the characteristic colors of autumn on the tundra.

Two things constantly baffle and mislead the eye in . . .
Alaska . . . size and distance. . . . The eye says it is three
miles to such a point and it turns out six; or that the
front of yonder glacier is a hundred feet high and it is
two hundred or more. . . . The wonderfully clear air
probably had something to do with the illusion. Forms
were so distinct that one fancied them near at hand
when they were not.

—JOHN BURROUGHS, *ALASKA, THE HARRIMAN EXPEDITION*
(Dover Publications, 1986)

Mount McKinley, or Denali, which in Athabascan means "the Great >
One," is the highest peak in North America, towering above its
neighbors in the Alaskan Range at 20,300 feet. To reach its summit is
a six-week climb even for experienced mountaineers, who typically
are flown from Talkeetna to begin their ascent at Kahiltna Glacier.
The mountain was first summitted in 1913 by Hudson Stuck, and
annually lures about a thousand climbers, several of whom perish
every year because of the weather or exhaustion or both.

The spectacular colored skies of summer sunrises justify rising at 4:30 a.m. to see them.

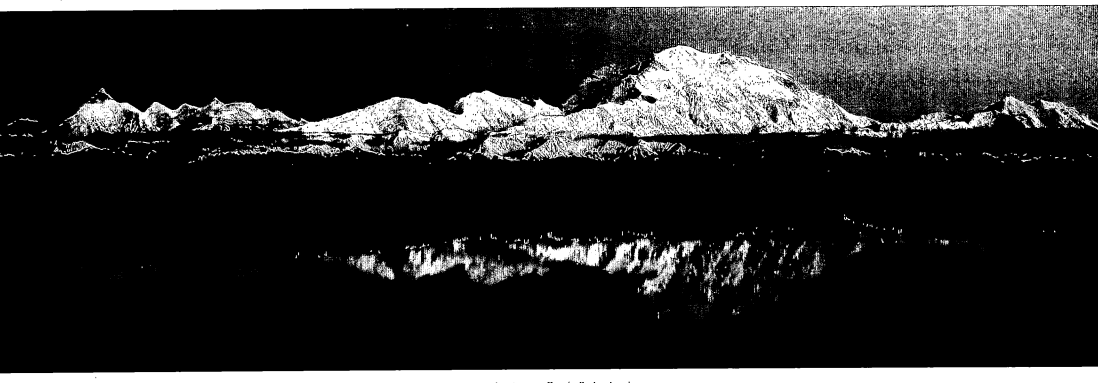

About an hour after sunset, pink reflections from the still-light sky color the mountain, creating a luminous effect called aplenglow.

In early September the sun sets at 9 p.m. During the seasons when daylight lingers longest in the Arctic, the sky never darkens completely.

In this fall view, shot at 1:30 a.m., the light of the moon is strong enough to create a glowing blue background for the mountain's white mass.

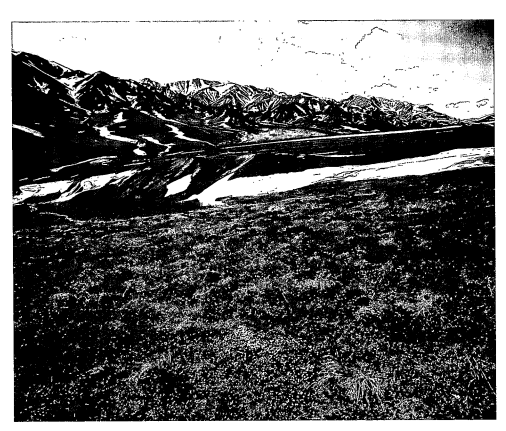

Lapland rosebay flowering on tundra in the Alaska Range,
Denali National Park

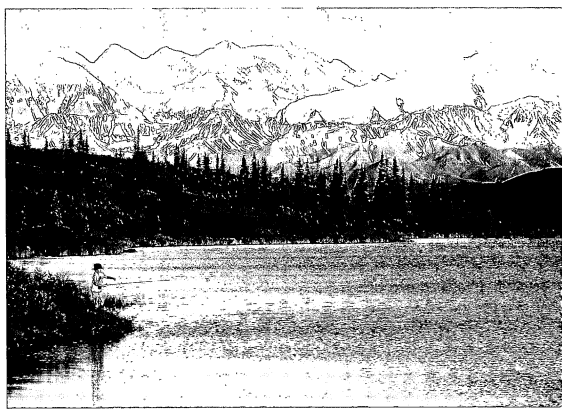

Photographer Roy Corral took this image of his daughter Hannah,
age ten, flycasting at Wonder Lake, Denali National Park.

Photographer David Muench captured this unusual juxtaposition of Mount McKinley and the autumn colors at Kesugi Ridge from Denali State Park.

We come to watch; to catch a glimpse of the primeval. We come close to the tundra flowers, the lichens, and the animal life. Each of us will take some inspiration home: a touch of the tundra will enter our lives—and, deep inside, make of us all poets and kindred spirits.
—ADOLPH MURIE, *MAMMALS OF MOUNT MCKINLEY NATIONAL PARK (Mount McKinley Natural History Association, 1962)*

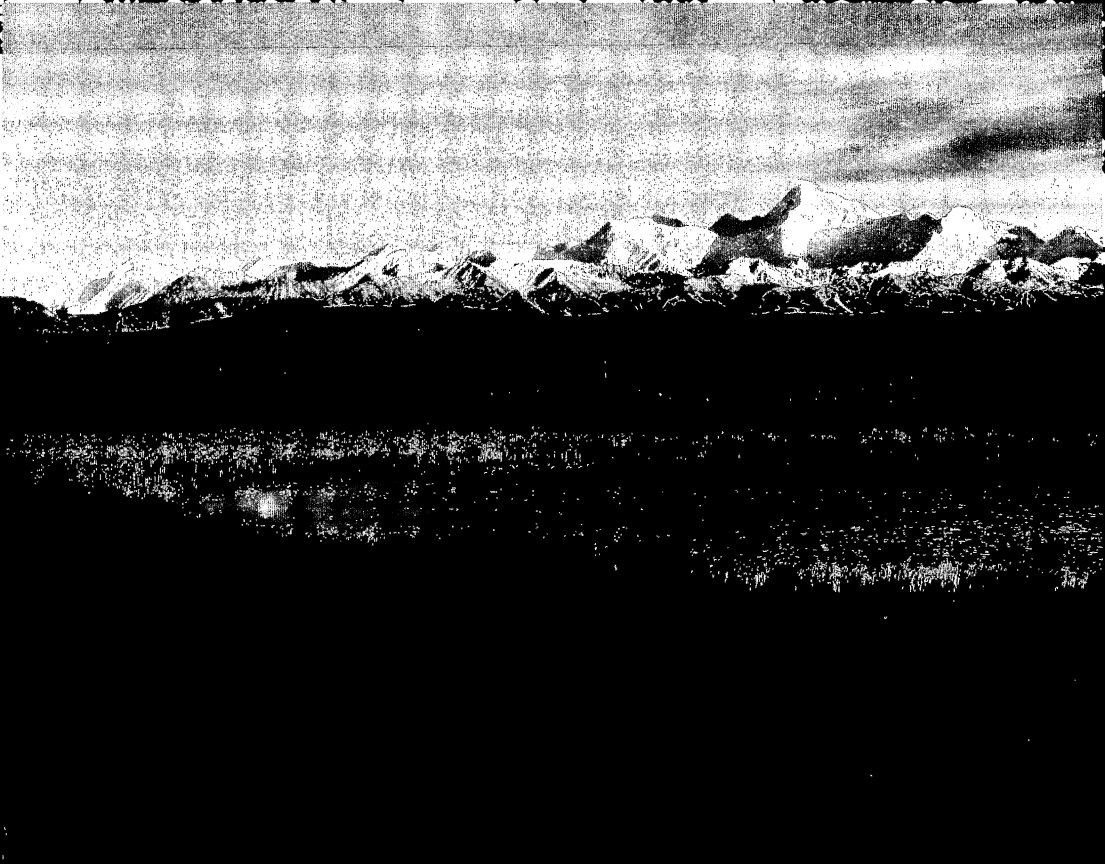

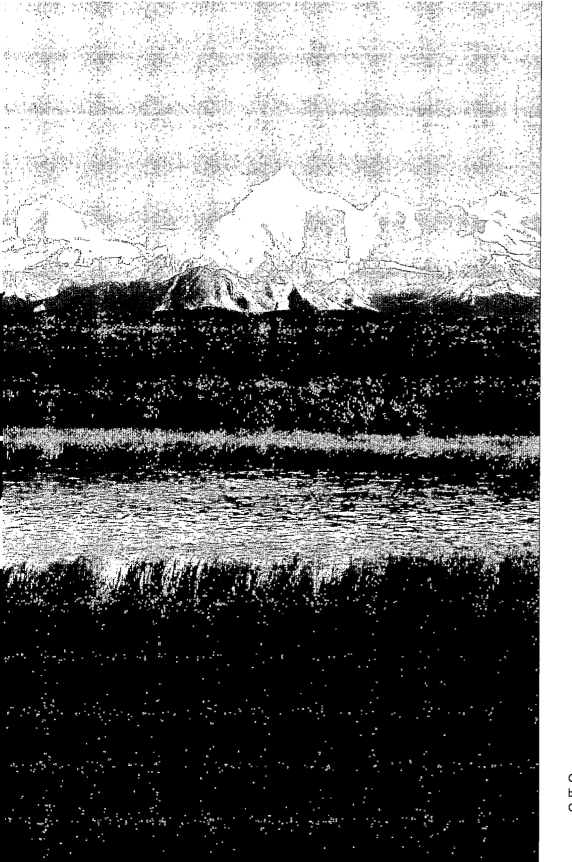

A two-year-old grizzly scratches an itch in Denali National Park.

OVERLEAF: Ron Klein shot this brooding image of Denali using a Cirkut camera.

Top: When the red salmon run peaks in July, brown bears use the occasion to prepare for the long winter hibernation by eating as many fish as they can grab from the water.

Bottom: Brown bear with her cubs at Brooks Falls, Katmai National Park

A small population of polar bears inhabits areas of Arctic pack ice, with females sometimes coming ashore to den and give birth.

Rainbow over band of Dall sheep rams grazing on tundra at Denali National Park

Everything seemed so good, so in place, so appropriate, in this remote terrain, that it didn't even seem wrong when we discovered that the sheep had somehow sensed our coming and were more than a quarter of a mile away . . . when we got to the place where we expected to find them.

—Robert Marshall, *Alaska Wilderness: Exploring the Central Brooks Range (University of California Press, 1970)*

Dall sheep along Seward Highway, Chugach State Park

Dall sheep are the only wild species of white sheep in the world. The age of these rams can be determined by counting the rings on their horns, which are retained for life.

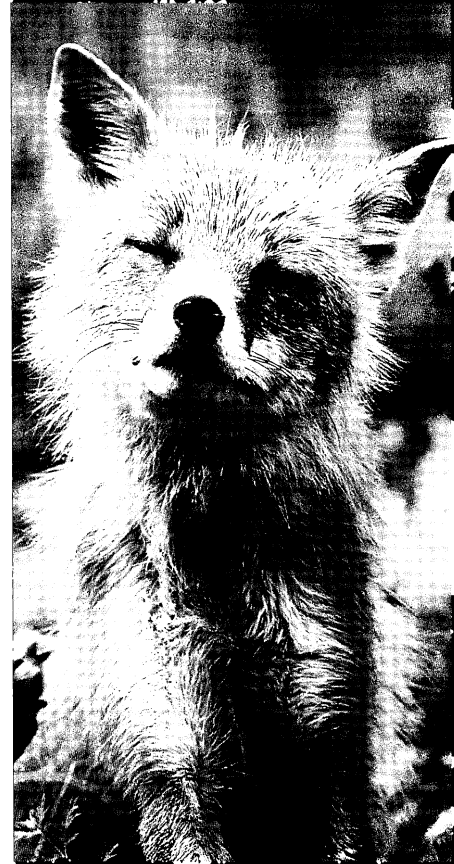

Although they are an important prey species in the wild, Alaska musk ox are also bred in captivity for the wool their thick coats provide.

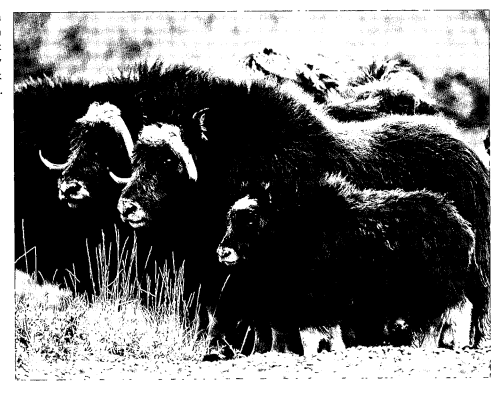

BELOW LEFT: Cuddly king of camouflage, an Arctic fox poses demurely on Alaska's frozen North Shore.

BELOW RIGHT: Arctic blue fox kits on St. Paul Island

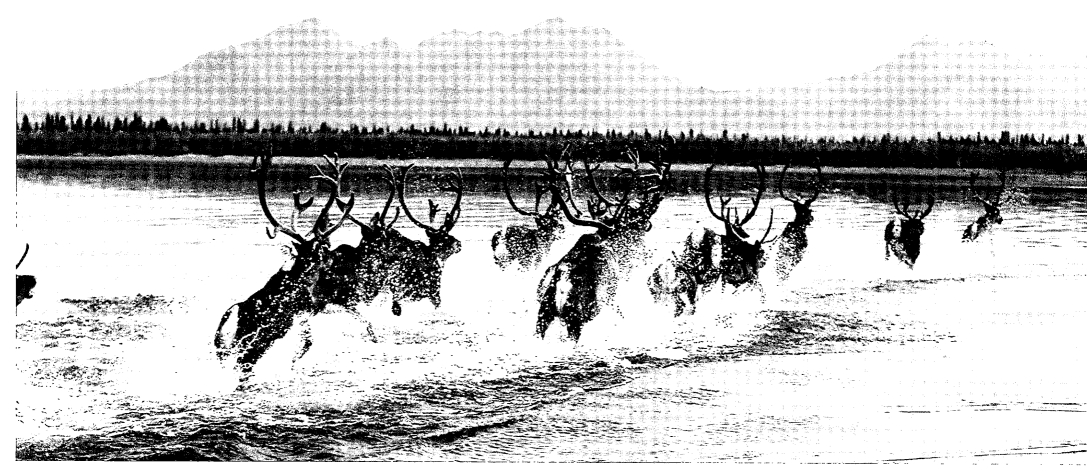

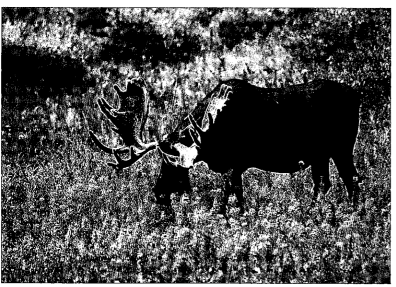

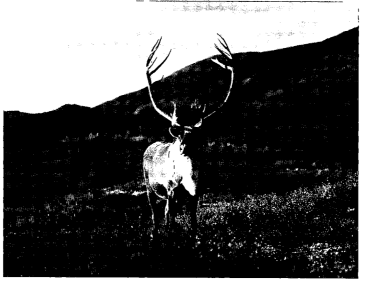

Top: Caribou populations fluctuate in Alaska, but within several major herds there are about 600,000 animals. They migrate several hundred miles each year, spending summers on eastern Arctic calving grounds, and winters in the northern Yukon. Because their diet is mainly lichen, Alaska's short growing season and harsh climate make available food scarce.

Although moose, like grizzly bears, seem to symbolize hearty Alaskan wildlife, they are in fact vulnerable to wolves, human vehicles, and starvation. But moose are also tenacious, and they thrive on lands summer fires have burned. These herbivores feed on willow trees and Alpine plant life like the green muck of swampy tundra ponds. This bull moose (left) has discovered fireweed in Denali National Park. A bull caribou (right) displays his antlers in Denali National Park.

Humpback whales bubble-net feeding on krill, Chatham Strait

The water is a sheet of glass, mirroring the light of the morning. The air is cool. If there are sounds, I don't hear them. My attention is fixed on that spot just beyond the rocks. The conditions are perfect for watching what I know is to come. I stand silent, arms crossed for a bit of warmth, determined to be a witness. I don't have to wait more than a few minutes before the bubbles begin to ripple the surface. They start at a fixed point and move clockwise in an arc, first away from shore and then back toward me in a continuing line around to the point where they began. The circle completes itself, and in seconds the water explodes in what appears to be mass confusion: the gaping mouths, warty heads, thrashing flippers, and spouting blowholes of three forty-foot whales.

Sea mammals, which had been essential to Native Alaskans for centuries, were also eagerly sought by Alaska's first colonists. Although they may be legally hunted for food, their populations are now thriving, having rebounded from overhunting in the late eighteenth century.

Pigeon guillemot investigates
Pacific walrus bulls

What I am witnessing is not confusion at all but the final movement in an intricate dance humpback whales sometimes engage in when they feed. The technique is called bubble-net feeding. Diagrams I have seen of it show a whale diving down to get under a school of krill or small fish, then blowing bubbles as it swims gradually upward in a spiral. The rising bubbles eventually form a cylindrical net around the krill or fish, effectively herding them into a confined area. The whale then lunges to the surface inside the circumference of that cylinder, mouth open, engulfing everything in its way.

—Carolyn Servid, *Surroundings*
 (Quarterly 59, Spring 1991)

Although fewer than twenty species of birds are common year-round in Alaska, it is a perfect environment for migrating birds, which visit from every continent to breed. Alaska's unrivalled population of seabirds, at 120 million, is sustained by several factors: a long and biologically productive coastline, a profusion of edible plant life and insects produced by long summer day-light, a diversity of habitats, and not many predators.

Top: Migrating sandhill cranes of Matanuska Valley

Middle Left: Red-necked grebe fishing at Anchorage Coastal Wildlife Refuge

Middle Right: The speckled brown feathers of the willow ptarmigan change gradually to winter plum-age, which is white for seasonal camouflage.

Bottom left: Short-eared owl hiding in tundra grass, Dalton Highway near Deadhorse

Far right: Horned puffins on rocky ledge, Round Island, Walrus Islands State Game Sanctuary

The bald eagle (*Haliaeetus leucocephalus*), the most common species in North America, is wholly brown when young, but in full adult plumage, it has a white head and neck feathers and a white tail. The two birds (top) who lack the characteristic white head and tail feathers are immature, less than five years old.

BOTTOM: Trumpeter swans, native to coastal areas from the northwestern United States through Alaska, are the largest swan species and, as their common name suggests, are capable of producing very loud sounds.

The unique topography of Katmai National Park is the result of a cataclysmic volcanic eruption. In 1912 Mount Katmai turned out to be a volcano when it erupted with ten times the force of Mount St. Helens, and left behind a landscape of barren beauty. The park is also home to mountains, a rugged coastline, and more than 800 Alaska brown bears.

Patterns in melting snow, Aleutian Range, Kamishak area, Katmai National Park

Top: Bald eagle nest on Basalt Cliffs, Amalik Bay, Katmai National Park

Research Bay, Katmai National Park

OVERLEAF: Brooks Falls, on the Brooks River
at Lake Naknek, is a favorite salmon-fishing
ground for Katmai's brown bears.

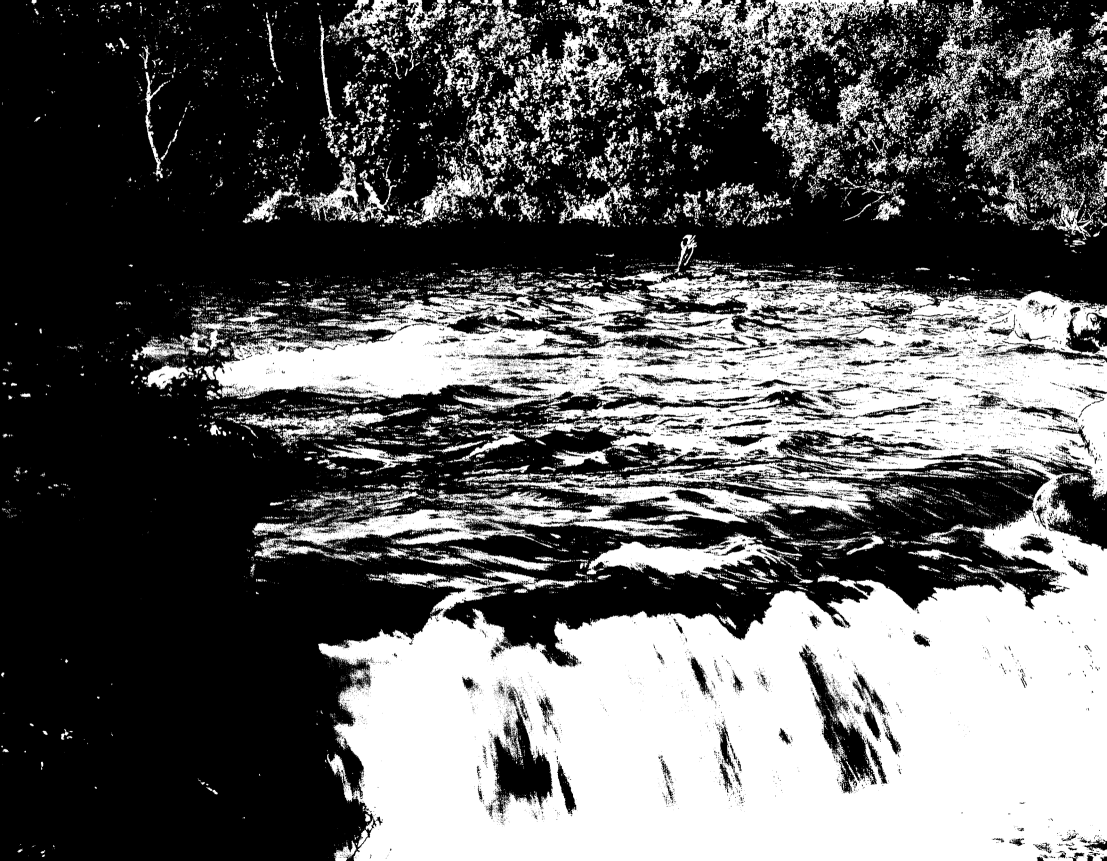

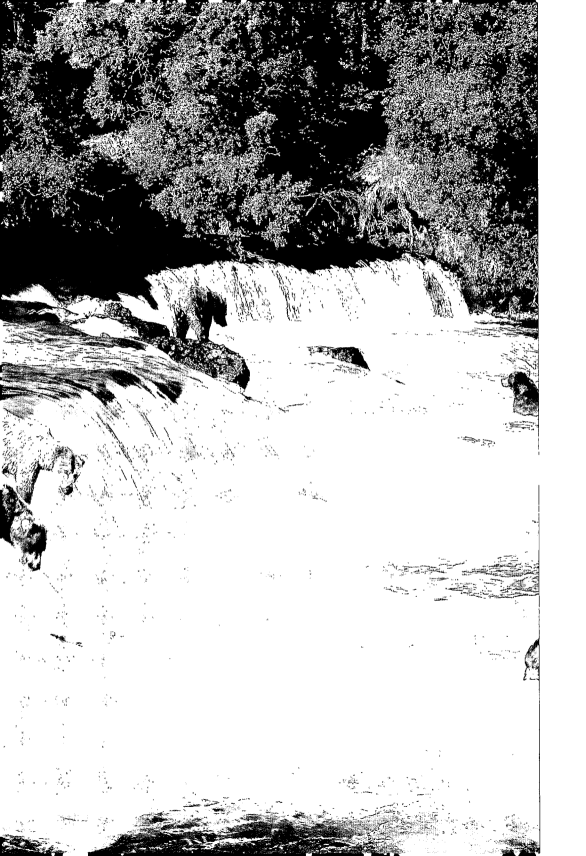

Bear tracks in moss, Katmai National Park. The Alaskan brown bears of Katmai can weigh up to 900 pounds, fattened by the big and abundant salmon of the Brooks River. The tracks of these behemoths are unmistakable.

One might assume that the desolate, tree-less, storm-swept Aleutians would have been avoided by primitive man. On the contrary, they were densely populated in prehistoric times. When discovered by Bering in 1741, the native inhabitants of the Aleutian Islands are estimated to have numbered from 20,000 to 25,000, more than the aboriginal Indian population of the Ohio Valley, or of Florida, New York State, or New England. The Aleutians abounded in animal life—whales, seals, sea lions, sea otters, birds, fishes, mollusks and other invertebrates—and it was this assured food supply that made it possible for such a relatively large number of people to live in so limited an area. Whatever other disadvantages it may possess, the Aleutian region, with its myriads of birds, abundant marine life, and rich and varied flora, cannot be described as "lifeless."

—HENRY B. COLLINS, JR., AUSTIN H. CLARK,
AND EGBERT H. WALKER, *THE ALEUTIAN ISLANDS: PEOPLE AND NATURAL HISTORY*
(Smithsonian Institution, 1945)

Russian Orthodox cemetery and Aleut village of St. Paul, Pribilof Islands

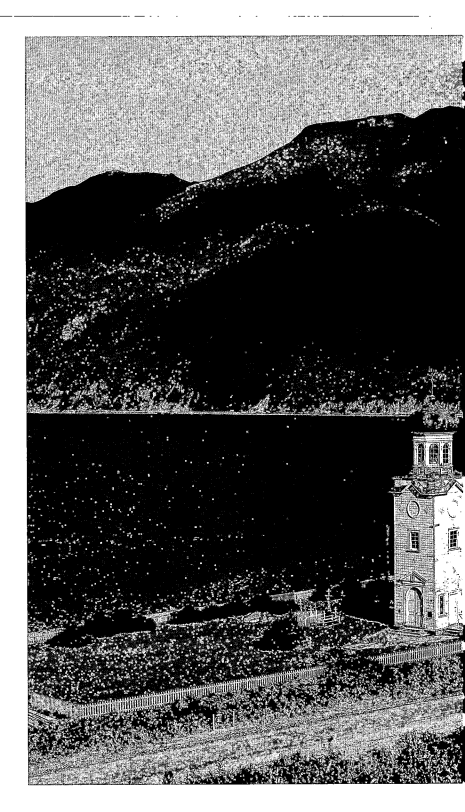

The white onion-domed Holy Ascension Cathedral, built in 1896 on a site that had been used for a church since 1808, is one vestige of the Russian Orthodox faith. Orthodox Christianity was established on the island in 1824, when Russian priest Ivan Veniaminov made inroads with Aleut natives by translating the Gospels into their language.

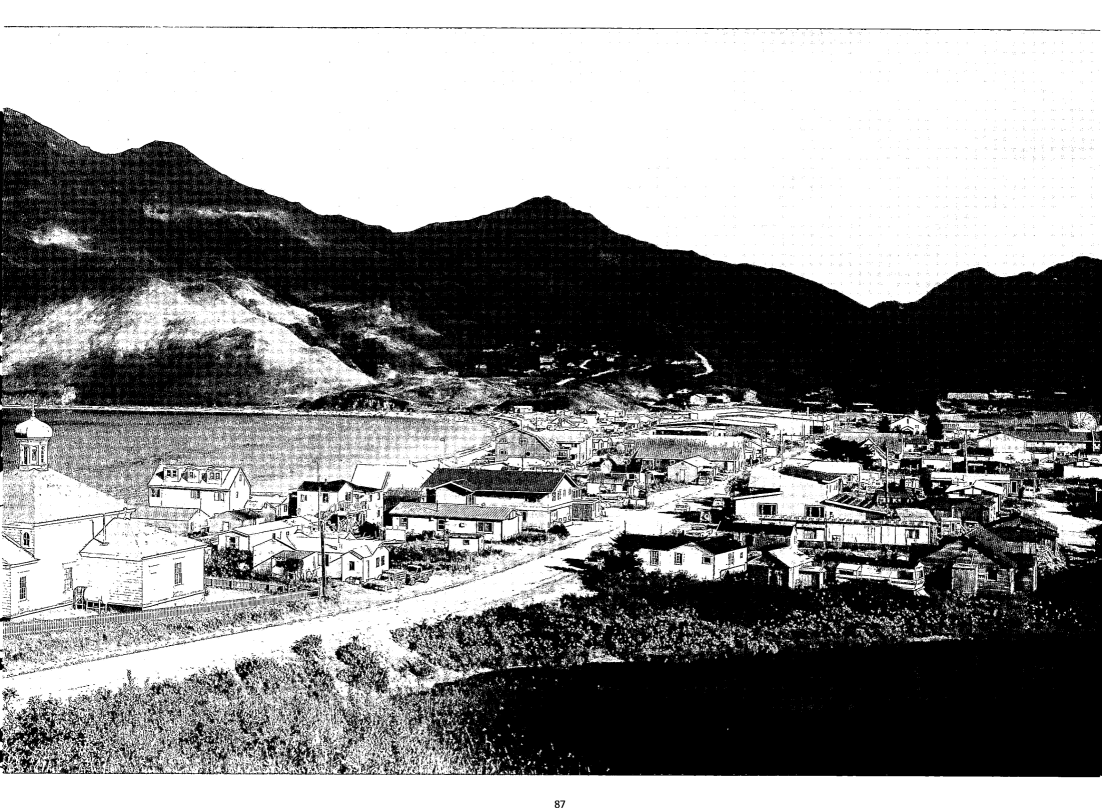

Trees planted by soldiers during World War II on Atka Island in the Aleutian Islands National Wildlife Refuge

St. Paul Island, one of the Pribilof Islands, is a tiny wind-blown place in the middle of the Bering Sea, teeming with marine mammals and sea birds. Some 600,000 fur seals gather at the breeding rookeries in summer, and birdwatchers travel to this remote location where two million birds of more than 200 species inhabit the rocks.

Walking is not easy on this island. There are no well-worn paths anywhere except to the spring, where we get our drinking water, about a mile and a half away from here. . . . The longer walks I had once anticipated taking so far have proved to be short excursions only. Some obstacle—such as slippery rocks, deep ravines, sudden fissures or bogs—always stand in the way of going on to the farther rookeries.

—LIBBY BEAMAN, *LIBBY: THE SKETCHES, LETTERS AND JOURNAL OF LIBBY BEAMAN (Council Oak Books, 1987)*

Arctic poppies and Wooly Lousewort

Bering Sea Water Carpet

Coastline of St. Lawrence
Island, Bering Sea

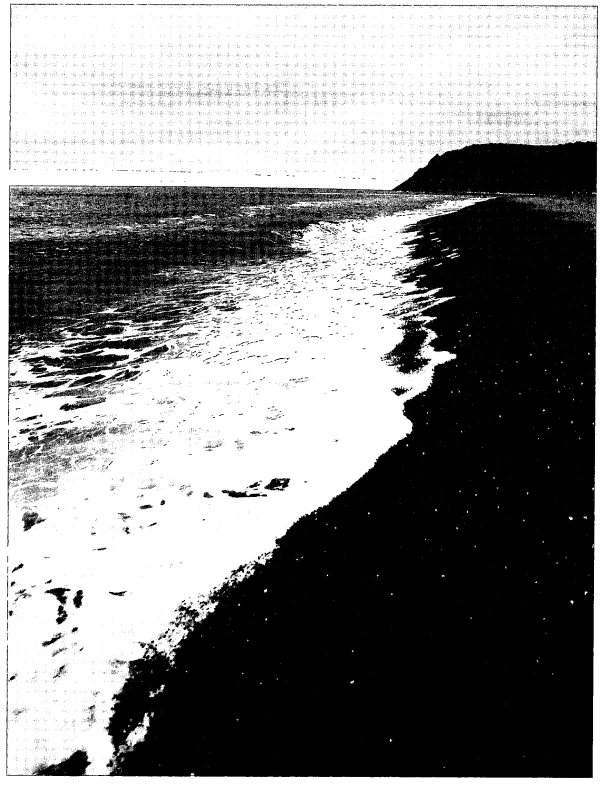

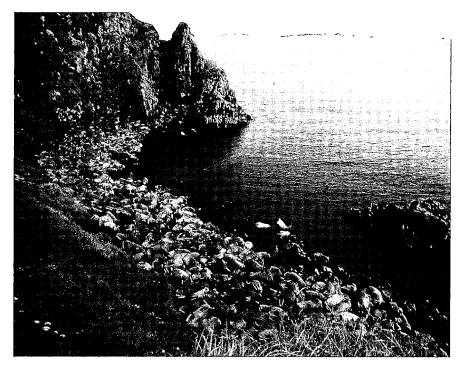

Male walruses hauled out on Round Island, Walrus
Islands State Game Sanctuary

St. Lawrence Island, south of the Bering Strait, is the
location where Alaska was first sighted by Russian
explorer Vitus Bering in 1728. The island has been
inhabited for several thousand years, and its people
are descendents of Siberian-Yupik Eskimos.

Arctic Forget-me-nots

Chickweed Flower

Midnight light on cottongrass on Kigluaik Mountains, Seward Peninsula

Above the Arctic Circle, Cape Krusenstern National Monument is a formidable landscape of lagoons and windswept beaches cutting into the Chukchi Sea.

The Arctic has strange stillness that no other wilderness knows. It has loneliness too—a feeling of isolation and remoteness born of vast spaces, the rolling tundra, and the barren domes of limestone mountains. This is a loneliness that is joyous and exhilarating. All the noises of civilization have been left behind; now the music of the wilderness can be heard. The Arctic shows beauty in this bareness and in the shadows cast by clouds over empty land. The beauty is in part the glory of seeing moose, caribou, and wolves living in a natural habitat, untouched by civilization. It is the thrill of seeing birds come thousands of miles to nest and raise their young. The beauty is also in slopes painted cerise by a low-bush rhododendron, in strange mosses and lichens that grow everywhere, and (to one who gets on his hands and knees) in the glories of delicate saxifrage, arctic poppies, and fairy forget-me-nots. The Arctic has a call that is compelling. The distant mountains make one want to go on and on over the next ridge and over the one beyond. The call is that of a wilderness known only to a few. It is a call to adventure. This is not a place to possess like the plateaus of Wyoming or the valleys of Arizona; it is one to behold with wonderment. It is a domain for any restless soul who yearns to discover the startling beauties of creation in the place of quiet and solitude where life exists without molestation by man.

—WILLIAM O. DOUGALS, *MY WILDERNESS: THE PACIFIC WEST* (Doubleday, 1960)

TOP: Moose and goose tracks near the Kobuk River, Kobuk Valley National Park

BOTTOM: Archaeological excavations begun in the 1950s revealed Cape Krusenstern's 114 beach ridges to be a highly significant repository of Arctic cultural history. Evidence of occupation by every major Arctic Alaskan culture beginning with the Denbigh people five thousand years ago was uncovered by archaeologist J. Louis Gidding.

The Kobuk Sand Dunes, covering twenty-five square miles adjacent to the Kobuk River, are created by winds carrying sand out of the nearby Baird and Schwatka mountains. The most impressive ridges are found on the western perimeter of the dune field at Kavet Creek—Kavet means "moving sand" in an Eskimo language. Geologists estimate the dunes began forming 150,000 years ago, and at their peak covered a much larger area of Northwest Alaska.

Dogsledding, once a primary means of transportation throughout Alaska, is still practiced on the flat, frozen lands in the northern territories.

Onion Portage, Kobuk River. The Kobuk Valley marks the convergence of arctic and subarctic terrain, and is home to species as varied as migratory shorebirds, Dall sheep, beavers, otter, and caribou.

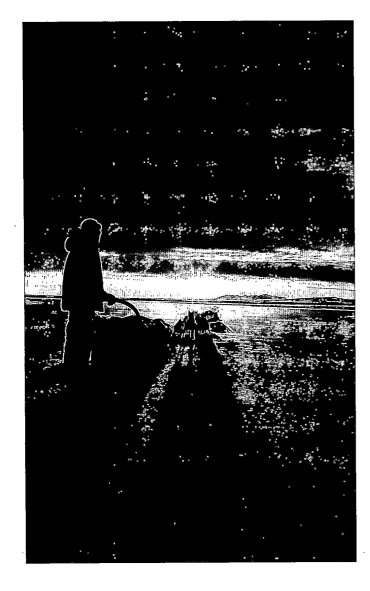

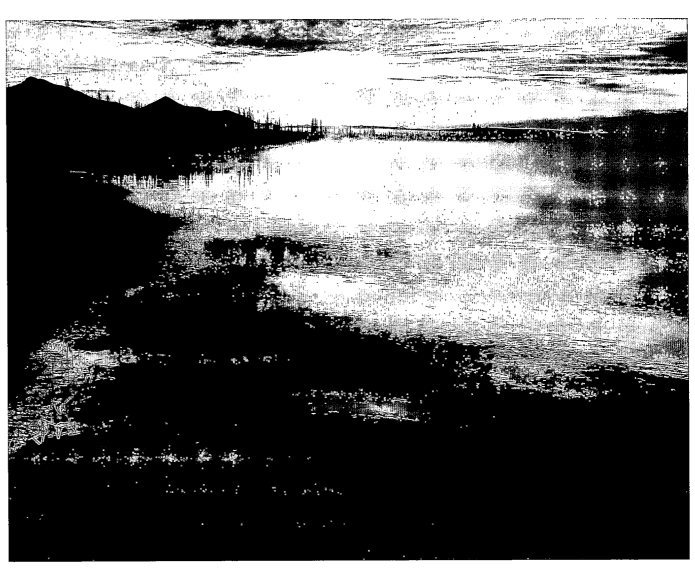

The Eskimo hunters say that in winter, caribou can hear a man moving across the snow a mile away. All the extraneous sounds of summer that distract and confuse—wind in trees, in willow and grasses, the humming of insects, whirring of wings, and the singing of birds, trickling melt and running streams—all are stilled by winter. When the thick blanket of snow and ice muffles the land, any sound breaking the silence is magnified a thousandfold.

—Billie Wright, *Four Seasons North*
(Harper & Row, 1973)

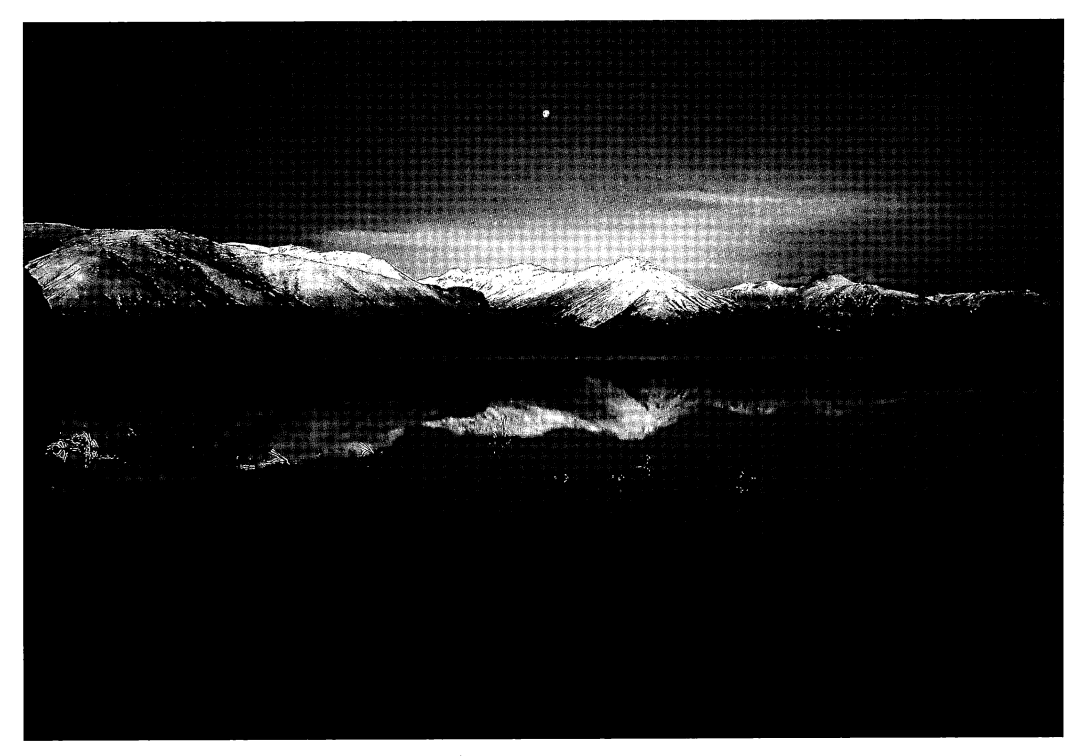

The Noatak River flows from Mount Igikpak, the highest peak of the Brooks Range, westward through Gates of the Arctic National Park to Kotzebue Sound and the Chukchi Sea. Its 450-mile-long course flows through steep canyons, gentle hills, boreal forest, and treeless plains.

Glacial erratic on tundra, Arctic National Wildlife Refuge, Brooks Range

Jago River flowing through the Brooks Range, Arctic National Wildlife Refuge

Beneath all those thriving blooms, all that Arctic beauty, is the solid
frozen ground. In August autumn paints the blueberry bushes,
cranberries, dwarf birch, and all other growth, and the landscape
takes on the colors appropriate for that season.

—OLAUS MURIE, *JOURNEYS TO THE FAR NORTH*
 (American West Publishing Co., 1973)

Kongakut River drainage in Arctic National Wildlife Refuge >

RESOURCE RICHES

OPENING THE TREASURE CHEST

FIVE MAJOR INDUSTRIES feed on the wealth of Alaska's land and water: oil, fishing, tourism, timber, and mining. A sixth decides who gets that wealth and when, and it employs more people than any of them: government.[1]

Less than 1 percent of Alaska land is in private ownership, so resource development cannot happen without government approval. At the same time, due to the size of the state and the difficulty of operating in its remote and rugged terrain, exploiting its natural resources requires huge investments. More so than in states with more diversified economies, economic issues in Alaska are political issues involving the interplay of industry, the land, and the people, issues that are played out in the board rooms of multinational corporations and in the halls of Congress.

Producing crude oil, moving it by pipeline across the state to tankers, and shipping it to refineries located primarily in the northwest U.S. dwarfs all other industry in Alaska. (The 800-mile Trans-Alaska Pipeline cost $8 billion to build in 1975–77 and was the largest privately financed construction project in world history.) Oil not only funds Alaska's government, it also fills a state savings account called the Alaska Permanent Fund, which has grown from less than a million dollars at its inception to $28 billion in 2008. The Alaska Permanent Fund receives an automatic share of the state's oil revenue, which is invested in securities and real estate. After reinvesting a portion of the income to protect the principal from inflation, the balance of the investment income is divided in two, with one-half available for spending by the legislature. The other half is paid out each October to all Alaska residents as dividends, which have averaged over $1,100 annually over the last decade (to 2010).

In addition to distributing oil wealth, state and federal officials must decide each year where the next set of oil wells will be drilled. Mindful of the environmental devastation caused by the 1989 *Exxon Valdez* spill, fishermen are wary of seeing rigs in their waters, threatening the marine habitat that supports them. With oil on the North Slope slowly running out, Alaska is waiting for the next stage in its economic development. Since its peak in 1988, when a quarter of the nation's domestically produced oil flowed through the Trans-Alaska Pipeline, the number of barrels of oil has dropped by two-thirds (to 650,000 barrels per day in 2010); Alaska now supplies about 11 percent of U.S. domestic crude oil. The pressure to explore more broadly and relax environmental restrictions builds with declining production and the loss of easy oil wealth. Eventually, of course, all the oil inevitably will be gone, but it's been so good for so long Alaskans want to put off that day as long as possible. True to the pattern of Alaska's history of resources and politics, however, the decisions about oil's future will be made far from Alaska, in business headquarters in Texas, New York, London, and Washington, D.C., where Congress controls the biggest oil prospects in protected conservation lands.

THE FISHING ADVENTURE

Fishing is Alaska's largest private employer and second-largest economic power, after oil. Towns and villages along the state's more than 35,000 miles of shoreline breathe in rhythm with the sea. When salmon return to their spawning streams in the spring and summer, cannery workers return to the tent cities, fishermen bring the boat harbors alive, and the stores and bars ring with voices. Bank accounts drained over the winter refill like reservoirs catching summer rain. In the fall, when the fish are gone, life slows again. Fishermen leave for vacations; deck hands and workers on cannery "slime lines" go back to college or to winter jobs. Nature and commerce seem to exhale together, as the streets empty, the leaves change, and sunset falls in the afternoon. It's all new every year, yet nothing seems to change. Only the wealth of the year's runs determine a town's prosperity.

In the salmon fishery, the self-reliant skipper still drives his own small boat in competition with others to take home the most fish and money. Bottom-dwelling fish and crustaceans, however, have become big business. Huge vessels trawl pollock from the floor of the ferocious Bering Sea, ignoring vicious storms, and transform the fish into surimi, a colorless, odorless protein paste that can be shaped into imitation crab, fish sticks, and other processed foods. Most of the vessels don't make their home port in Alaska,

traveling to the fishing grounds directly from bases in Seattle. Instead of wits matched in competition on the high seas, the companies' executives compete in government councils to obtain an advantageous allocation of the offshore resources.

Outside forces are starting to intrude on this intimate relationship between fishing towns and their environment. For the towns to survive, the world must buy their fish, but competition from salmon farmed in pens in Scandinavia and South America

grows ever greater. Meanwhile, the public is buying less canned salmon, one of Alaska's major products.

Like each of Alaska's basic industries, fishing will always draw on public resources, and how those resources are divided up will always rest ultimately with the government—free competition on the open seas is only one possible model for how to determine winners and losers. Resource development in general always will require big investments, world markets, and favorable political conditions.

TIMBER VS. FISH VS. TOURISM

Imagine a rain forest glade, where misty, sap-infused air clings to moss, ferns, and massive tree trunks so tall the sky seems to shrink in their high reach. A stream splashes over rocks, clear and cool in the shade of the trees. In the stream, salmon ruck up the gravel to deposit and fertilize their eggs, spawning another generation. In the trees, eagles, owls, and falcons nest or scan for prey. Somewhere beneath the trees, bears and wolves are prowling.

What's this place good for? Fishermen say it's good for nursing young salmon, which they later catch to pay boat loans and house mortgages. Ecotourism guides say it's good for filling date-books with visitors who have money to spend on a trip to Alaska. Tourism is booming all over Alaska, topping 1.5 million visitors a year—twice the state's population (710,000 in 2010). More than half of the visitors come on huge, white cruise ships that sail north on week-long voyages from Vancouver, B.C., through the ports of Southeast Alaska's Inside Passage, then to Seward, near Anchorage, where passengers board planes home again. In summer, little southeast towns are as

Gold dredges like this one in Fairbanks floated on a pond of their own making. A shovel would excavate at one end, machinery inside would digest the gravel and separate out the gold, and the waste would refill the pond behind the dredge.

crowded as big cities, their streets packed with tourists visiting from cruise ships.

Tongass National Forest in Southeast Alaska, at 17 million acres, is the nation's largest rain forest. Wrangell had grown into the largest town in the area since its first sawmill was built more than one hundred years ago. But the fast-paced, federally subsidized logging caught the attention of a nation newly concerned about protection of the world's rain forests in the 1980s. Here North America's last, large stands of primeval, old-growth timber were going under the saw for less than the cost to the taxpayers of building the necessary roads and other infrastructure. When the government faced environmental protests and lawsuits, the Forest Service canceled contracts to log the Tongass. Wrangell's mill shut down in 1994, and one-third of the local payroll disappeared. Townspeople cursed faceless environmentalists somewhere back east who seemed to care more about trees than people. Then, ironically, as they looked at the town's future, their best hope seemed to be in bringing those same kinds of people to Wrangell. The town's greatest asset was the tourism potential of the area's rich natural environment. Today, the annual shorebird migration is the focus of a festival in Wrangell; more and more guides are leading tours to the nearby bear sanctuary; and the tourism bureau is working overtime to advertise the area's considerable natural beauty.

With the crowding has come the recognition that tourism isn't a benign industry, either. Locals complain that their favorite paths and beaches are being overrun, and charter boats fish out not-so-secret fishing holes. Quick, superficial tours that maximize their companies' income detract from the quiet and spirituality of the natural places they visit, and helicopters bring noise to wilderness areas. How much these inconveniences bother the local people depends on how much of their income derives from tourism. Like the mining, oil, and timber industries, big tourism requires big investments. The major cruise lines that make those investments also own bus and railroad cars, hotels, and even some historic sites. This "vertical integration" allows the company to ensure quality and also to capture as much of the visitors' spending as possible. Many tourism workers come from outside Alaska, too, as the short season and low pay of restaurant, hotel, and other service industries make it difficult to support the relatively high expenses of living in Alaska year-round.

Still, plenty of small-time entrepreneurs get a share of the summer flow of visitors, too. From bed-and-breakfast operators to sea-kayaking guides, they've grown more and more sophisticated at finding a niche and attracting part of the growing flow of tourists into it. To the experienced eye, an Alaskan tourist destination is a bit like a marine ecosystem: the season is short, and each small business, like little organisms on a reef, reaches out with different strategies to catch a share of the nourishing food flowing by in the ocean water. To succeed, they must get their fill before the weather turns, so they have reserves to survive the eight cold, dark months of the off-season.

NOTES

1. Neil Fried, Alaska Department of Labor, interview by the author, June 1997.

The Matanuska and Susitna Valley area, known as Mat-Su, is Alaska's prime farming country. Many of the Mat-Su farms were developed in the 1930s during a New Deal program which relocated several dozen Scandinavian-American families to Alaska from Wisconsin and Minnesota.

Top: Rural scene in Palmer
Bottom: Tanana Farmers Market, Fairbanks

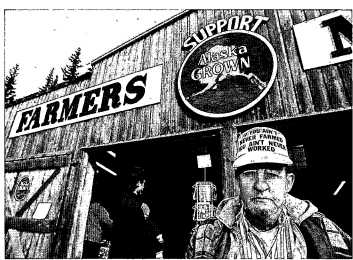

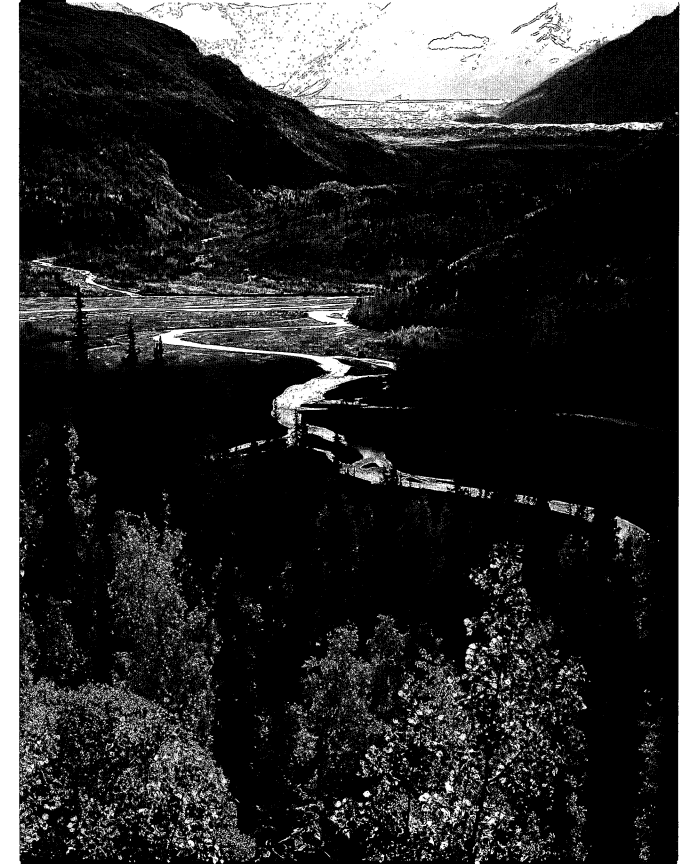

Potato harvest in the Matanuska Valley

Gene Dinkel, who farms in Wasilla, with a giant cabbage

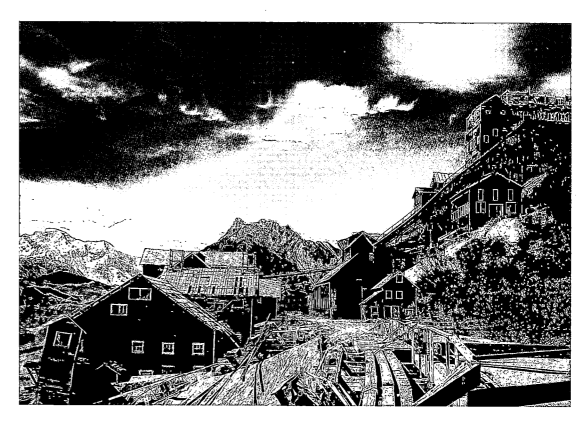

Kennicott, in the Wrangell Mountains, thrived as a town from 1910 to 1938, when one of the richest copper deposits ever found was actively mined there. Now it's a Park Service–preserved ghost town.

Anchorage's annual Fur Rendezvous is a winter festival featuring sled-dog races through downtown and opportunities to buy furs (the commodity that first brought colonists to Alaska).

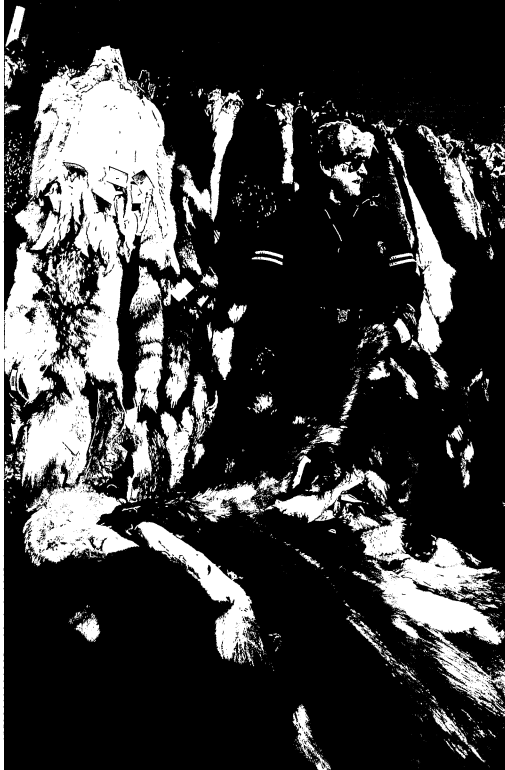

Steve Vlahos, an oyster farmer at Fairmont Bay in Prince William Sound, displays a day's haul. Alaska's commercial fisheries produce half of the world's fish protein, and fish are vital to the subsistence economies of many Native villages.

TOP RIGHT: Shrimp harvest from Unakwik, western Prince William Sound

Crab traps

OVERLEAF: Dutch Harbor at Unalaska, which has grown from a Russian-occupied Aleut town to become the hub of the Alaskan fishing industry, is also Alaska's oldest town.

OPPOSITE: Fishing fleet in the harbor at Homer on the Kenai Peninsula

RIGHT: Spring snow falls on a fishing boat in Halibut Cove. The most famous halibut fishing takes place in Homer. Halibut up to 300 pounds thrive in and around Kachemak Bay, an area of exceptional biological productivity.

BELOW LEFT: Commercial fishing for herring in Sitka Sound

BELOW MIDDLE: Salmon spawning, Valdez

BELOW RIGHT: Salmon hangs on a drying rack along the beaches of Norton Sound near Nome. Native fishermen know their salmon so well they can easily tell from which river a single King Salmon has come.

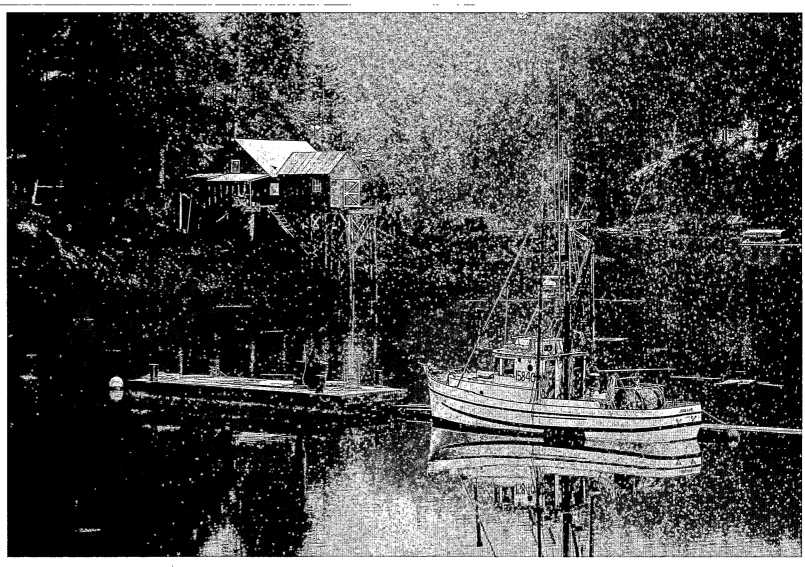

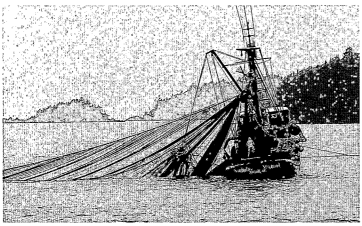

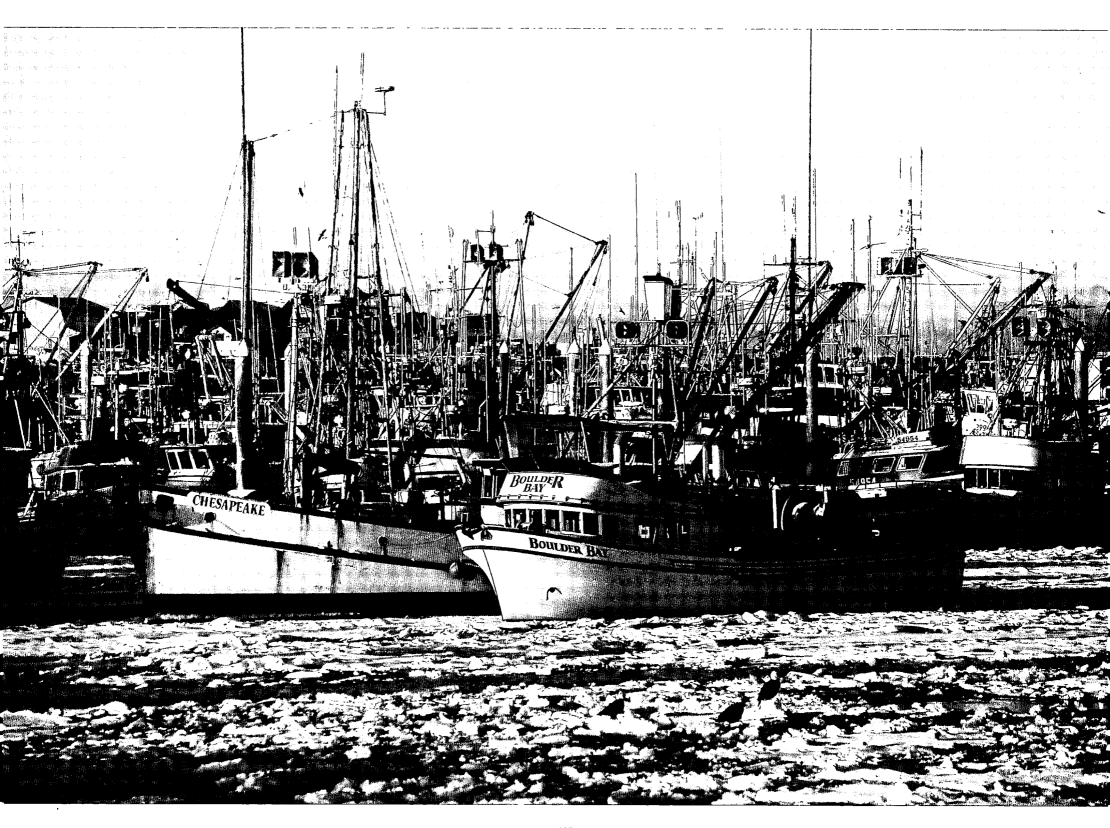

Roughly speaking, the land that has been built upon, pipelined, or otherwise trammelled in Alaska—all the land that is now taken up by towns, villages, cities, airports, trapper cabins, motels, roads—consists agglomerately of less than a hundred thousand acres. That leaves, untouched, nearly three hundred and seventy-five million acres. By almost any standards drawn from the North Temperate Zone, human settlement is still the next thing to nonexistent in Alaska.

—John McPhee, *Coming Into the Country*
 (Farrar, Straus and Giroux, 1977)

The Trans-Alaska Pipeline carries oil through the Alaska Range on its 800-mile trip from Prudhoe Bay oil fields to the port of Valdez. Discovery of the Prudhoe Bay fields in 1968 necessitated a pipeline to transport the oil south. The land-ownership issues provoked by the pipeline's proposed path resulted in compromises that ultimately mapped out the state's present configuration of Native-, federal-, state-, and privately owned lands.

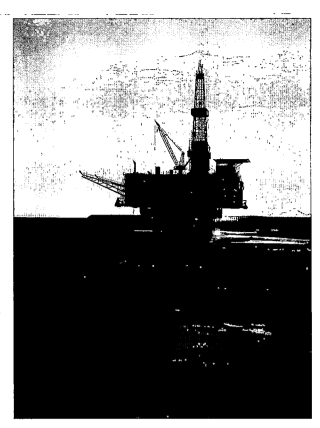

Early afternoon sunset on ice-filled Cook Inlet silhouettes an oil production platform lit for the impending long night. The 1957 discovery of oil fields in Alaska created an economically viable future for the territory, and so strengthened the case for statehood.

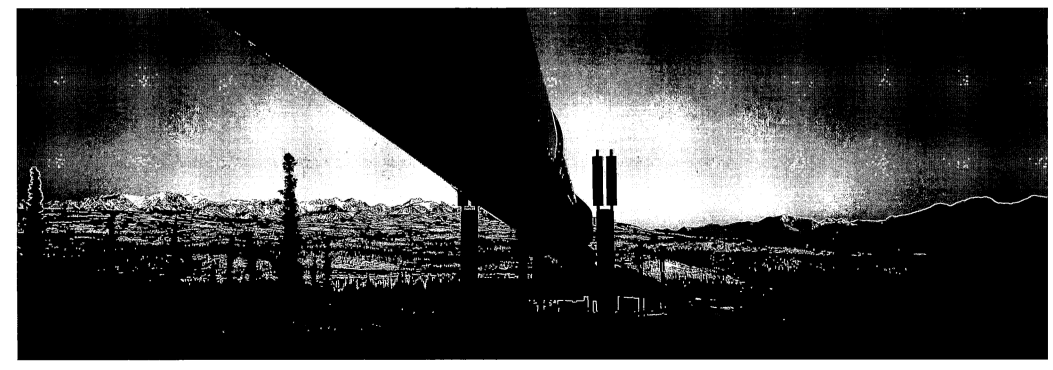

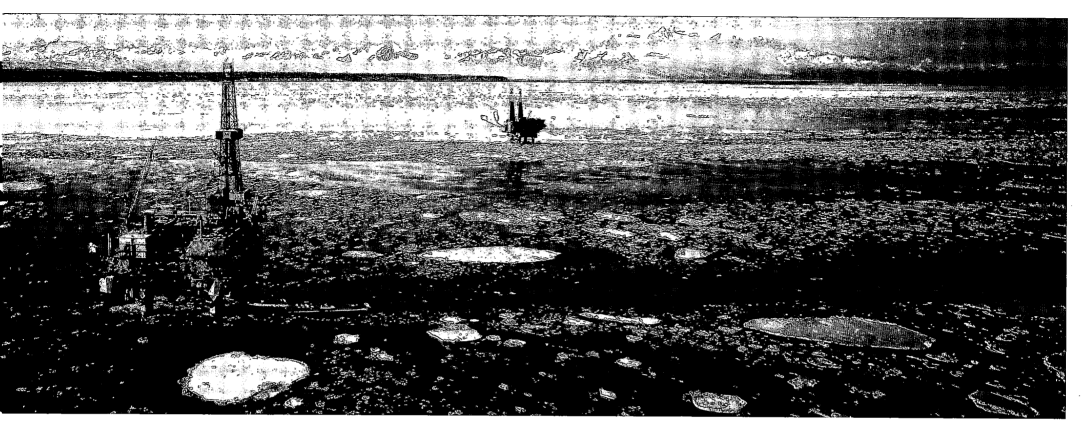

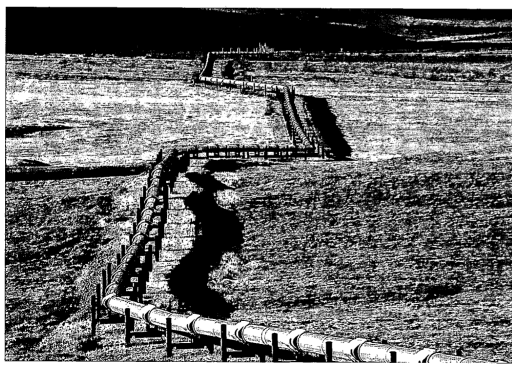

Trans-Alaska Pipeline at Atigun
River Valley, Brooks Range

Cruise ships bring tourists to Skagway, at the head of the
Inside Passage waterway, to see the town that drew perhaps
20,000 people during its peak Gold Rush years, 1897–1899.

View of Hubbard Glacier in
Disenchantment Bay from the
deck of a Cunard Line cruise ship

Cruise ship in Prince William Sound, >
near Columbia Glacier

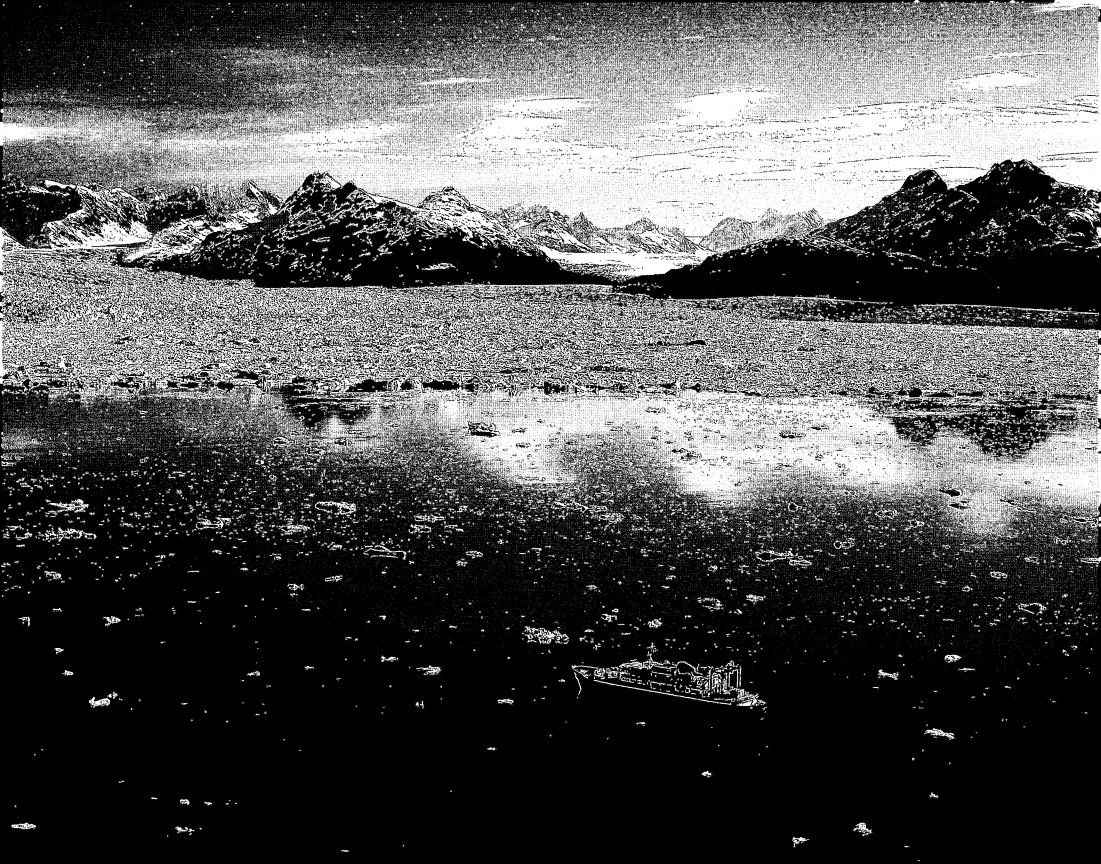

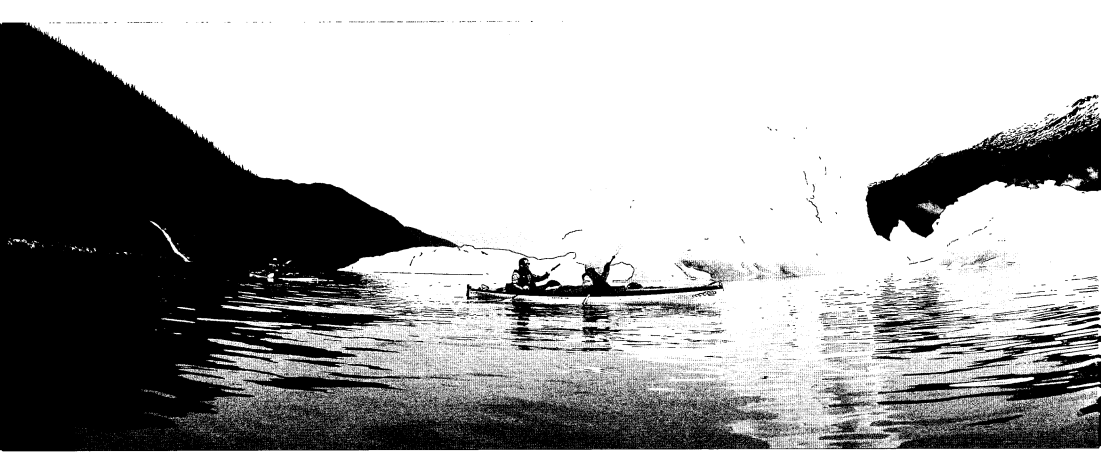

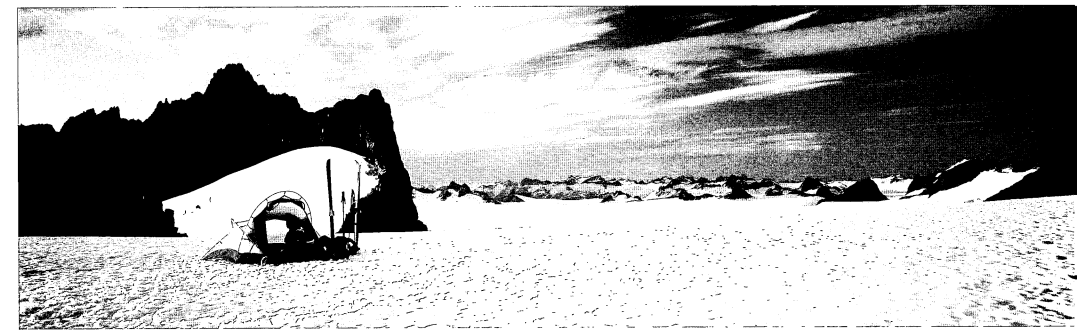

LEFT: Kayakers pass icebergs at a glacier snout.

BELOW: A fisherman has traveled by kayak to a solitary spot on the shore of Lake Beverly at Golden Hornwood, Tikchik State Park.

Hiking on tundra above Sable Pass in Denali National Park

When the salmon run is at its peak, accessible spots (like this one on the Kenai River) attract so many fishermen that the sport is known locally as "combat fishing."

< Skiers camped out on Rhino Peak overlook the enormous Juneau Icefield in the Taku Range.

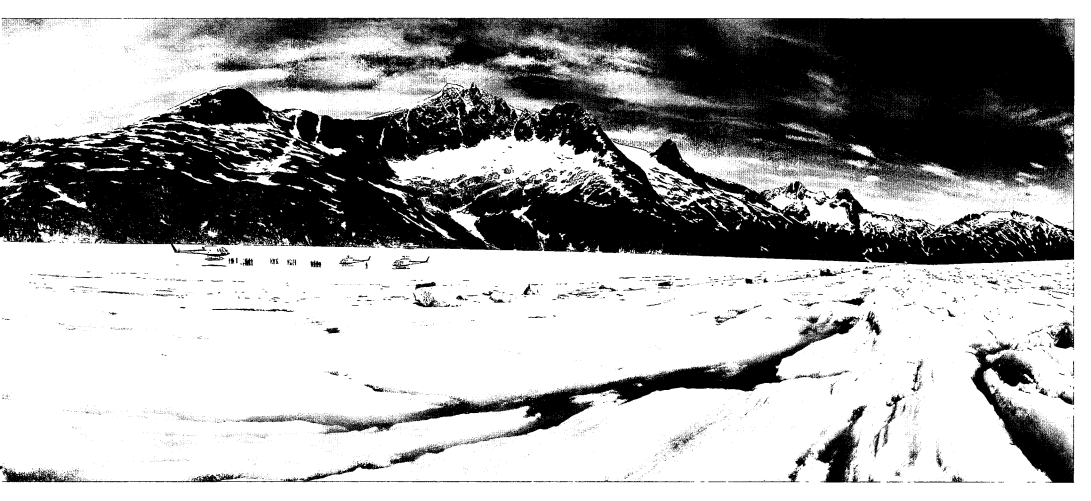

Although Mendenhall Glacier is one of the few that can be easily visited, touring it by helicopter provides a humbling sense of its immense scale.

LEFT: Salmon fishing near Kaflia Bay, Katmai National Park

RIGHT: Floatplane over medial moraines, Tongass National Forest

OPPOSITE: Camping at Margerie Glacier, overlooking the peaks of the Fairweather Mountains

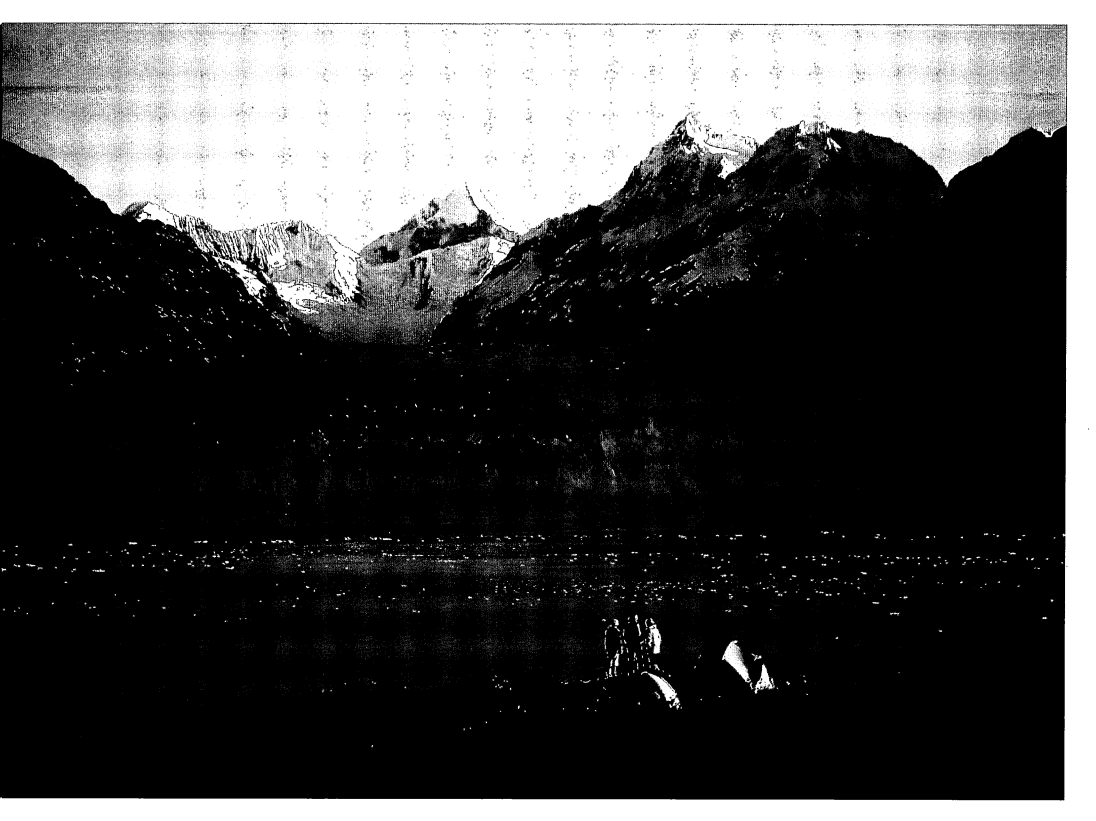

LIFESTYLES

LIVING WITH THE LAND

LONG AGO, at a place called Ukkuqsi, five Inupiat women and girls lay in a traditional house of whalebone, earth, and planks surrounded by practical belongings they had made with their own hands: a needle case, a sewing bag with animal sinews for thread, *ulu* knives, a hide scraper, a chamber pot. The women's life was hard. Their teeth were worn down from their work chewing hides. Their diet was meat, but they had lived through periods of near-starvation. Their lungs were black as a coal miner's from breathing the smoke from seal oil lamps that polluted their little home.

It was wintertime, and outside, a great storm was blowing off the Arctic Ocean. In the depth of the storm, with a great rumble and grinding, the thick sea ice, called *ivu*, overran their home. Pushed by the weather up onto the land, the *ivu* crossed the ground and fell on them, crushing all five to death and sealing them in the frozen earth.[1]

Hundreds of years passed. The shoreline eroded where the women had been buried and a body appeared, perfectly preserved by the frozen ground, lying just where it had on the day of the storm. A team of archaeologists hired by the Inupiat town of Barrow in 1982 happened to be in the village, and immediately encouraged the study of this site for its clues about early Eskimo life. The village elders knew the value of the bodies to teach the Inupiat about how their ancestors lived, too, but the excavation was allowed only on condition that the bodies would be treated with the proper respect called for by their culture. According to the traditional way of the Inupiat, the spirits of dead ancestors were to be honored, remaining present to guide gifted people who would listen to them.

The archaeologists' work went on deep into the white Arctic nights to preserve the frozen flesh before it could thaw. When the scientists had finished their analysis, cataloging 20,000 objects from several sites and documenting the hardships of the women and girls from the evidence of their bones, teeth, clothing, and flesh, all five bodies were returned to their people for proper burial.

Modern Barrow would be hard for the ancient Natives to recognize. The largest community on the North Slope, with a population that hovers around 4,300, Barrow lies 320 miles north of the Arctic Circle and 1,300 miles south of the North Pole. The oil-rich community has a large new school, well equipped with educational technology. A big borough hall and Native corporation offices house Inupiat politicians and executives handling millions of dollars, fully connected to the business world by computers. Modern Inupiat homes have satellite televisions that bring in a hundred channels of alien culture. Jet planes land every day. The frozen Natives' life of famine and hardship isn't even a memory.

But some things would be familiar. They would recognize the *nalukataq* ceremony, when the community honors its whaling captains who have brought home the year's bowhead whales in open boats. They would understand the spirit of the community when a whale is landed and hauled up on the beach, and everyone joins in butchering the meat and blubber, distributing every pound to all the people of the village. In the streets, they could hear their Inupiat language spoken, although they would not understand the form in which it is written on the street signs. They might recognize the traditional dancing, singing, and ivory carving that survive. But they'd be surprised to see the art's consumers: tourists who come from every continent.

To some degree, Alaska's Native people live in both these two worlds. Deeply linked to a place by kinship, tradition, and ancient languages, still they cannot avoid membership in a dominant culture which has so readily devoured many other minorities before. In some Yupik villages in southwest Alaska, the area least disrupted by outside contact, the old ways prevail, modified primarily by modern tools like guns and outboard motors. People still speak their Yupik dialects every day and live primarily on traditional subsistence foods such as salmon dried on outdoor racks, moose, waterfowl, and marine mammals. But in other villages, the balance is far more tenuous. A younger generation has been raised on television. Grandchildren may not share a language with their grandparents. While the young people gain sophistication in pop culture, they may lose something far more valuable and rare: a deep and unshakable knowledge of who they are and where they come from.

When Congress settled Alaska Native land claims in 1971, giving back 44 million acres of the state to its original inhabitants, residents of the North Slope cast the sole dissenting vote. The deal set up a new legal structure, which recognized that this land was essential to the Native way of life. But instead of creating tribal reservations, which seemed to be an economic failure in the rest of the U.S., the government transferred the land and $1 billion in seed money to new corporations whose shareholders were "all the Alaska Natives then alive." These for-profit corporations were expected to develop the natural resources such as timber and minerals on their land, with the goal of bringing Native people more into the nation's mainstream cash economy.

The corporations survive, some quite profitably, but many Native leaders have come to question the corporate model. Some Natives say an uneasy distinction divides "village Natives," who stay in the Bush, partly living a subsistence lifestyle according to the cycle of the seasons, and "corporate Natives,"

working more in a world of business suits, competition, and money. Another distinction is made by Craig Native Antoinnette Helmer: "Profit to non-Natives means money. Profit to Natives means a good life derived from the land and sea, that's what we are all about . . . Living off the land and sea is not only traditional, but owing to the scarcity of cash income, it is required for our families to survive."[2]

Village life is very different from "white man way," as the dominant culture is often called. A typical village has a few hundred residents and is accessible only by small plane, although snowmobiles and boats often provide a link to neighboring villages and summer fish camps. Usually there are only a few jobs—at the post office, the village store, the clinic, and possibly the Native corporation—so most cash comes from commercial fishing, arts and crafts, fighting summer wildfires, and government payments. The clock has little meaning through the long, indefinite summer days and winter nights that seem to melt one into the next. Large extended families care for each other without many of the formal lines of responsibility that segment modern city life, children wandering from house to house. Giving is honored more highly than acquiring.

For a visiting outsider accustomed to the hustle, stimulation, and written rules of life in the city, the village can seem desolate and inscrutable, a place of poverty and hopelessness. Indeed, alcohol abuse and suicide are serious problems among the young people. But, invisible to the superficial gaze of first-time visitors, Native culture may provide a rich sense of meaning based on values of place, unity with the natural world, cooperation within a community, and age-old tradition. It's not "white man way" at all. For Alaska Natives, the challenge is how to exist in a competitive, fluid, materialistic society, and also preserve their own, which is so much the opposite. How shall the descendents of the frozen family retain their ancestors' values while escaping their hardships?

A New City

For the last one hundred years, since the Klondike gold rush, non-Natives have outnumbered Natives in Alaska. One-fifth of today's population of 710,000, are Alaska Native, and 40 percent of Alaskans live within the metropolitan area of a modern American city: Anchorage, which has grown 12 percent in the last decade.[3]

Anchorage has all the advantages and disadvantages of any mid-sized American city: fast-food franchises and a symphony orchestra; high-rise office towers and low-income housing projects; freeways and air pollution; drug crime and bicycle cops. Some derisively call the city "Los Anchorage" for its sprawling, car-oriented urban design and cushy lifestyle. Not many other major cities have to debate whether to create a hunting season within city limits to reduce nuisance moose encounters, or have to close city parks due to infestations of aggressive owls or hawks. In Anchorage, it's possible to cross-country ski from one side of the city to another on groomed, lighted parkland trails. Big salmon are fished from urban streams, and less than an hour after quitting time a worker from the biggest office building downtown can be climbing a pristine mountain peak, alone.

Anchorage owes its unique qualities to its location and youth. Situated in a bowl rimmed by mountains and the silty, gray waters of Cook Inlet, the city lies on the natural route north to the Interior and south to the Kenai Peninsula. Unlike mountainside coastal towns to the south like Seward or Whittier, Anchorage has plenty of useable land and few natural barriers. The Anchorage bowl lacks major natural resources, but the city is a good hub to serve the rest of the state. It lies on the railroad and highway corridors through the center of the state and connects Alaska to the rest of the world through Anchorage International Airport, which is conveniently located to refuel planes connecting U.S. cities with Europe and the Orient.

Anchorage has been a gateway from its first day. In 1915 the federal Alaska Engineering Commission, charged by President Wilson and Congress with building a railroad that would open up the territory to resource development, chose the mouth of Ship Creek for a workers' encampment. The site was across Cook Inlet from the village of Knik, and the waters offshore were marked "anchorage" on nautical charts. The camp was called various names, but Knik Anchorage stuck, and was later shortened to Anchorage. The commission chose this construction workers' tent city, about a quarter of the way along the railroad's route from Seward, a seaport on the coast to the south, to Fairbanks, in the center of the state, as a good, central headquarters. Officials surveyed streets, platted and auctioned off lots, and built clapboard cottages for employees to live in. A railroad official took charge of governing the new town.

Anchorage was a small town of mostly railroad employees until World War II and then the Cold War brought an explosion of military construction. Development was fast, functional, and ugly: corrugated metal Quonset huts became residential neighborhoods, strips of cinder block boxes defined commercial districts. It was a rough, dusty, wide-open

town. Few really believed in Anchorage—as one pioneer told me, the town didn't even seem permanent, just another boom town to go and make some money in before moving on. Only with the discovery of oil on the Kenai Peninsula in 1957 did Anchorage receive the push it needed to become a significant city and center of commerce, a place that would last. North Slope oil and the money that flowed from oil-enriched government grew it more; by the early 1980s, glass-walled office buildings and fancy subdivisions popped up like mushrooms after a rain. People began adding flowers and trees, and taking more pride in how the town looked. On a sunny weekend or long summer day after work, the town explodes with young, well-off families bicycling, in-line skating, or heading out to fish or hike. At times, anything seems possible, and Anchorage is like a bright kid, fresh out of high school, a promising life ahead of her, and a few things still to learn.

Into the Country

Roads reach only a few narrow strips of Alaska, but lone, self-reliant people live in many places. In exchange for the hardships of providing their own heat and water, catching and hauling their food, and divorcing themselves from many of the things money buys, they receive solitude, a place of their own in a beautiful land, and a sense of freedom. To get home, they fly small planes, drive boats, travel cross-country, or ride the flag-stop train from Anchorage, one of the nation's last. For electricity, they run generators; for transportation, ride snowmobiles and all-terrain vehicles; for heat, cut cords of wood with chainsaws and axes. For money, most work a few months a year in town. Guns provide dinner and protection from bears. To keep the life-giving machines working, they need to be able to fix everything themselves, often in the cold or without proper parts or tools. For their children, they must be teacher, nurse, and playmate.

The Federal Homestead Act ended in the Lower 48 states in 1976, but persisted in Alaska for another decade. The State of Alaska still has a program to provide residents with homestead land, but you couldn't say the land is free: to get it, you have to build a home in the wilderness and live in it twenty-five months within five years. Most of the parcels the State gives out come back because people just can't make it so far from civilization.

Of Fish and People

Somehow, each salmon knows when to return to the stream of its birth. King salmon live in the ocean five years or more. Then a certain month and week arrives—it's different for each river and each run, but the same for all the fish in any particular group—and the salmon turns on its incredible homing sense, a sense of smell that can find the flavor of a particular creek in all the water of the broad ocean. On schedule, each fish drives upstream for all it's worth to spawn and die in the place where it started life.

Human life follows the same cycle, returning annually to the same streams and ocean waters, following the salmon. All over Alaska, the return of the salmon brings the excitement of flashing, muscular flanks and the richness of firm, delicious flesh, a shared sensual renewal after the cold, lifeless winter. There's a sense of unity in the summer's surplus of daylight and energy. The arrival of the fish represents sustenance, both physical and spiritual. Here is something that can be trusted: a miracle that happens every year, just the same.

The first few fish come in May, appearing fresh in Anchorage grocery stores with the fanfare of a new season. June offers the early runs, indicators of how the fish will be this year. In July, the fish hit hard, filling rivers all over the state. Villages empty as Alaska Natives return to traditional fish camps, working as extended families to catch and dry or smoke fish for winter. Commercial fishing fleets stand ready for official openings, then fish around the clock. Sport fishermen line the banks

Tlingit dancer Charles Jimmie Sr. performing a ceremony for a bald eagle release in Klukwan

of road-accessible streams, and tourists come by the thousands to small coastal towns—for the fishing and to see bears gather around the salmon streams. In the fall, the rivers thin out, and spawned-out carcasses, picked over by birds and animals, become fine-boned skeletons on the river banks, elegant two-dimensional patterns against the gray gravel. In November, the very last run of salmon returns to the Chilkat River, near Haines, where the warm water stored in riverbeds over the summer wells up in the winter, keeping the surface clear of ice. Thousands of bald eagles congregate for the year's last easy meal, filling the leafless branches of old cottonwood trees. In the town, an eagle festival celebrates their coming and the very end of the season.

Winter drapes the land in white as if for storage until spring. People hibernate like bears, dropping into a quiet season. The salmon are away at sea, and last generation's eggs lie in the gravel streambeds, waiting for spring. Frozen or smoked, the taste of last year's catch barely excites the memory of that glorious, wild fish when it was fresh. A cold snap freezes cars in the city and grounds planes in the Bush, completing the isolation. Children go to school and come home in the dark, sometimes carrying books home under the Northern Lights. Eyes forget what brightness looks like.

From the ancient Native village to the rich, new Anchorage subdivision, the promise of next spring's first salmon remains alive.

NOTES
1. John E. Lobdell and Albert A. Dekin, Jr., "The Archaeological, Human, Biological and Comparative Contexts of a Catastrophically Terminated House," *Arctic Anthropology 21*, No. 1 (1984).

2. Thomas R. Berger, *Village Journey* (New York: Hill and Wang, 1985).

3. http://2010.census.gov/news/releases/operations/cb11-cn83.html.

Yupik Eskimo women cut salmon for drying in Hooper Bay

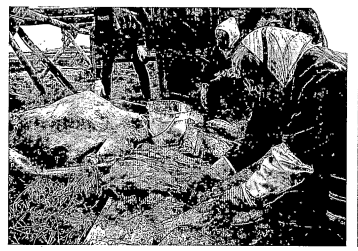

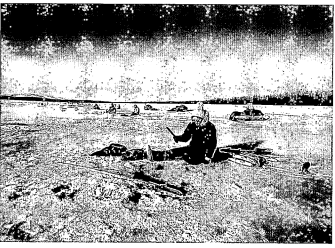

Inupiat youth and a whale bone backlit by midnight sun

Young boy in Gambell, a Siberian Eskimo village on St. Lawrence Island

The annual gathering of the Southeast Pan-handlers Bike Club was recorded in 1988 on a Cirkut camera. Its large format captures the elaborate costumes of riders and beautiful condition of their motorcycles.

Athabascan youth checks family's salmon
drying on a rack in the village of Minto.

Anchorage's International Ice Carving Festival, held
each March, makes the most of winter weather.

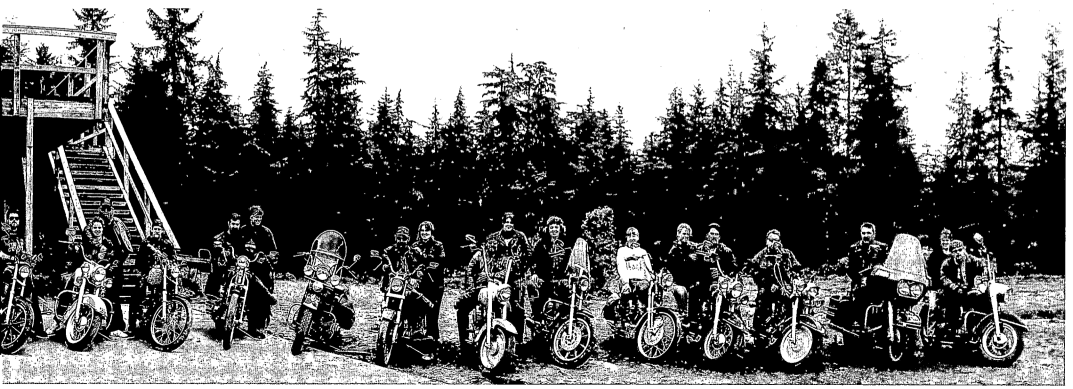

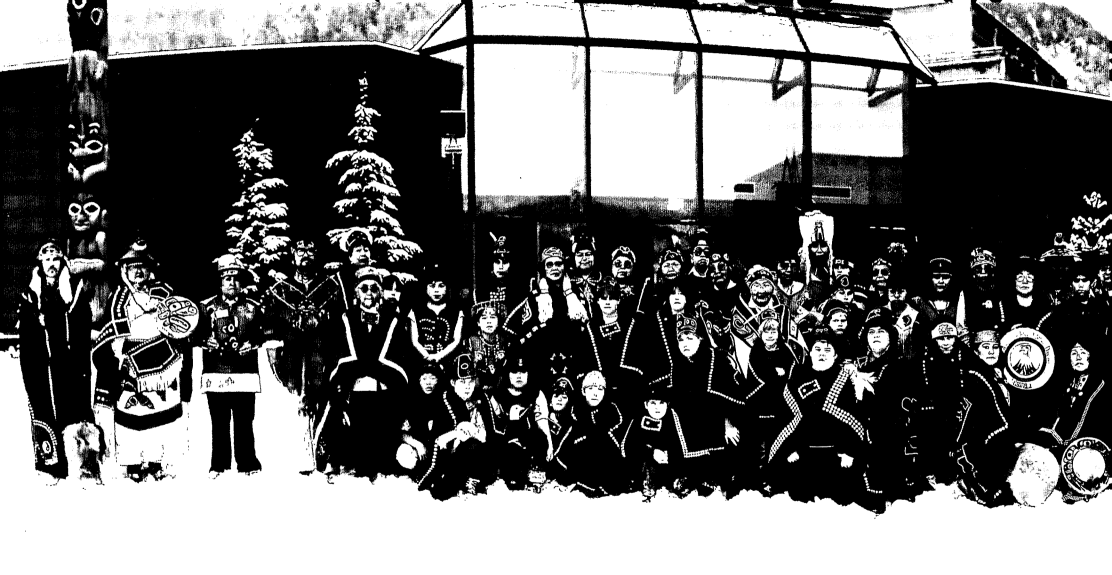

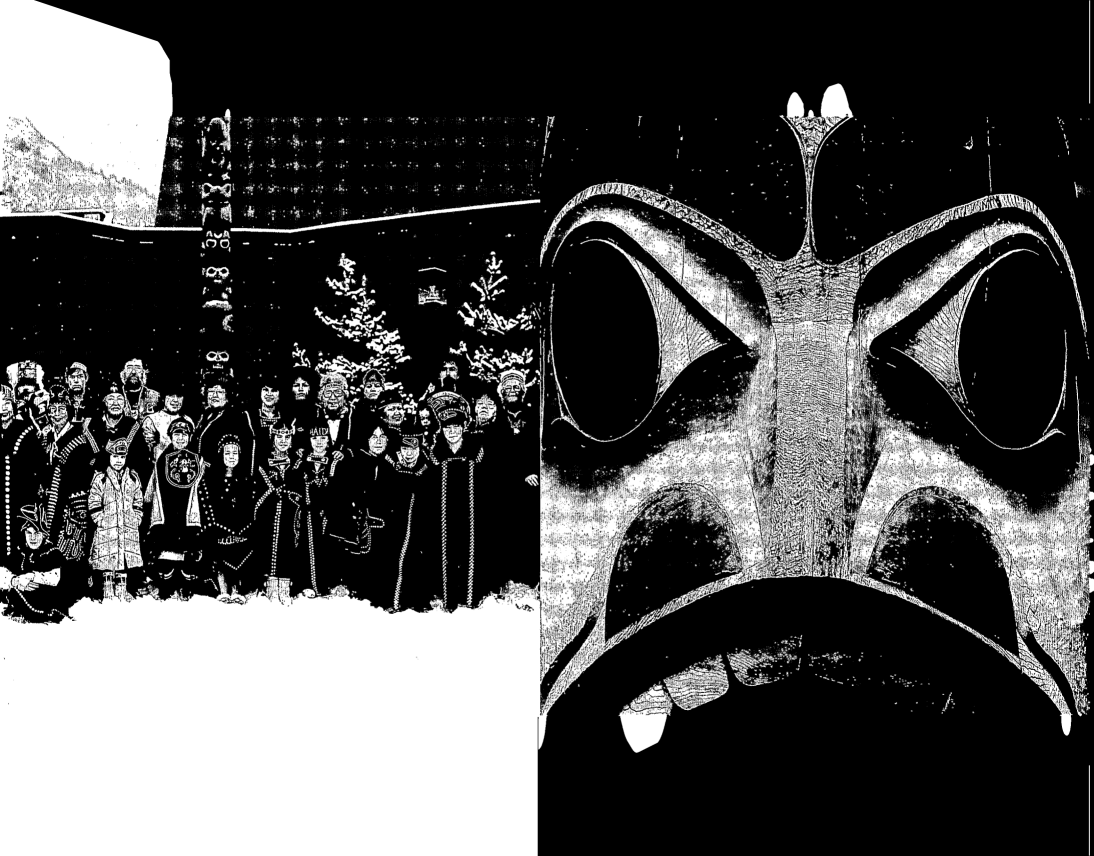

FOLDOUT: All the members of one Tlingit clan pose in ceremonial dress with totem poles installed at the Southeast Alaska Indian Cultural Center in Sitka.

PREVIOUS PAGE: Yaadaas crest from corner pole in Sitka

BELOW: Aerial view of braided river on frozen tundra

BELOW: Sled-dog mushing in Alaska is a form of transport, a professional sport, and a new form of recreation. The Iditarod race commemorates the heroic sled-dog journey of 1920, when Nome was threatened by a diptheria epidemic and serum was carried there from Seward, 1,300 miles away.

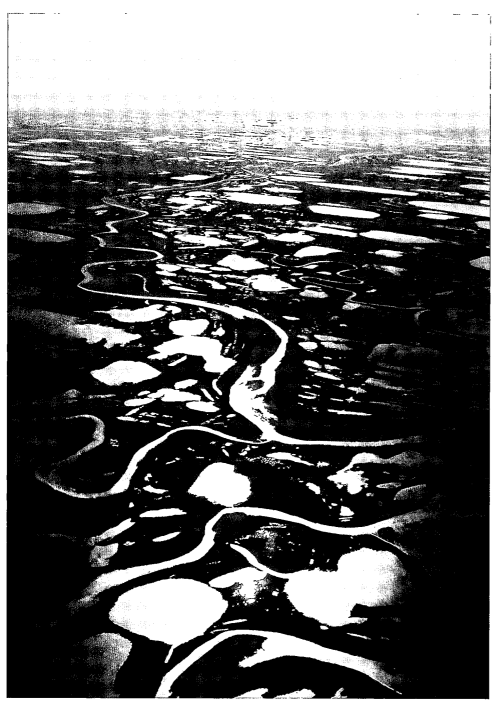

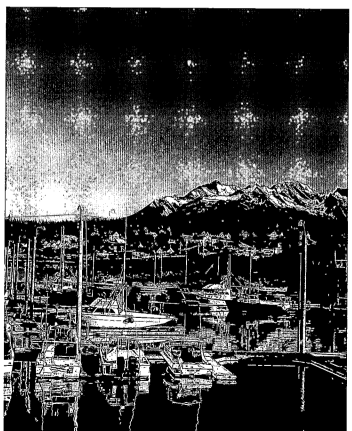

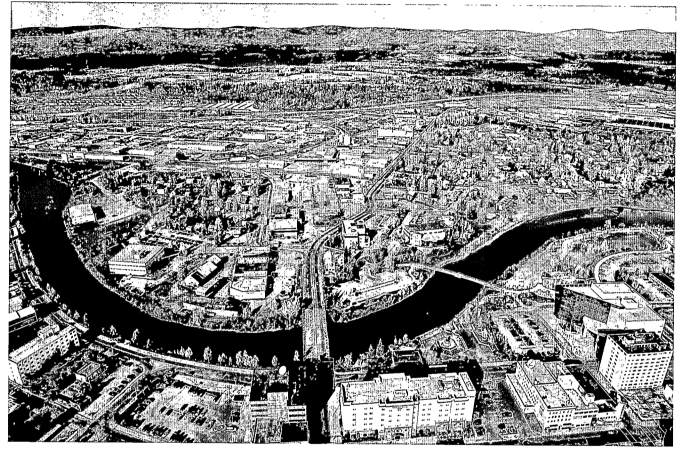

Fairbanks has evolved from a Gold Rush town to a World War II aviation hub to its current status as Alaska's second-largest city and an important center for trade and transportation between the Interior and the Far North. It is home to the University of Alaska's main campus and to three military bases.

LEFT TOP: Archaeological digs have dated the human occupation of Kodiak to almost 5000 B.C. and allowed its people to restore some of the rich Alutiiq culture effaced by Russian colonization in the late 1800s. Kodiak is now a busy Bush town, and Alaska's largest fishing fleet operates from its harbor.

LEFT BOTTOM: Haines is a small coastal town tucked away in the upper reaches of the In-side Passage's Lynn Canal. Though its Tlingit history and culture are still visible and active, Haines also has a significant colonial and federal past. It was chosen by John Muir and missionary S. Hall Young as a site to bring Christianity and education to Alaskan natives in 1879, and later was home to the U.S. Army's Fort William Seward, built in 1903 and commissioned until the end of World War II.

Jet planes and the ferries of Alaska Marine Highway are the only way in and out of Juneau, Alaska's capital and third-largest city. Hemmed in by mountains and the formidable Juneau Icefield, it was founded in 1880 when Joe Juneau was led by Tlingit chief Kowee to gold reserves, which fed its economy for the next sixty years. This winter view of the capital was shot from Douglas Island in 1988 before a tramway was installed on Mount Roberts (to the right).

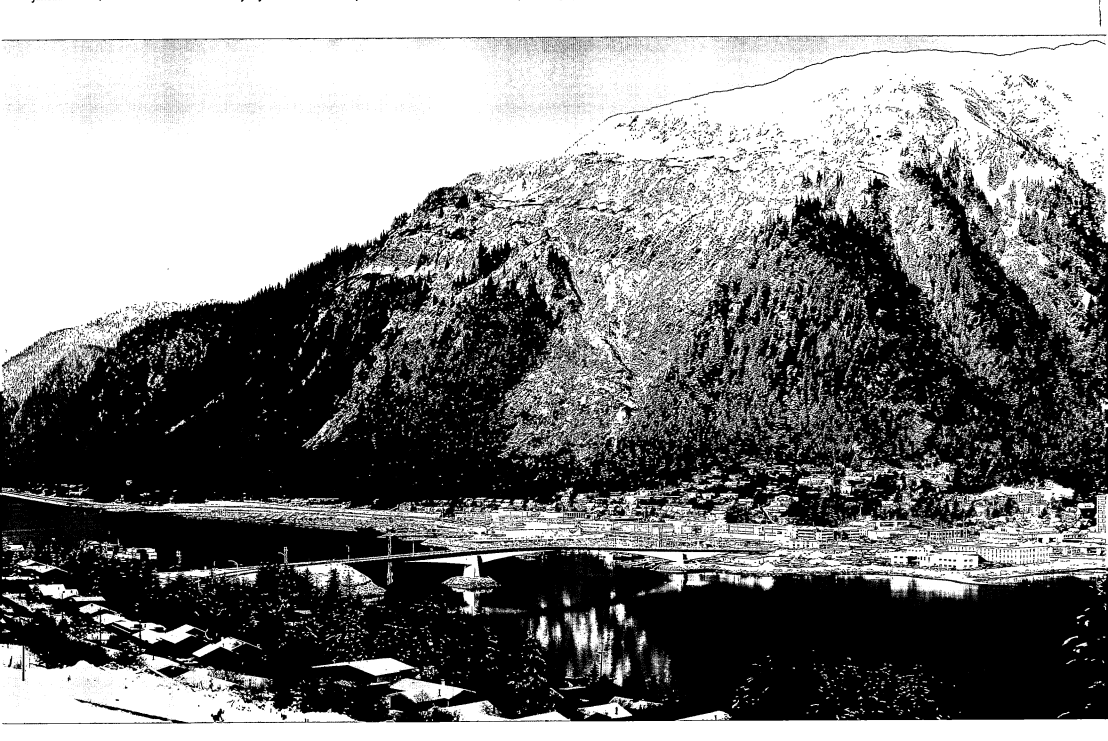

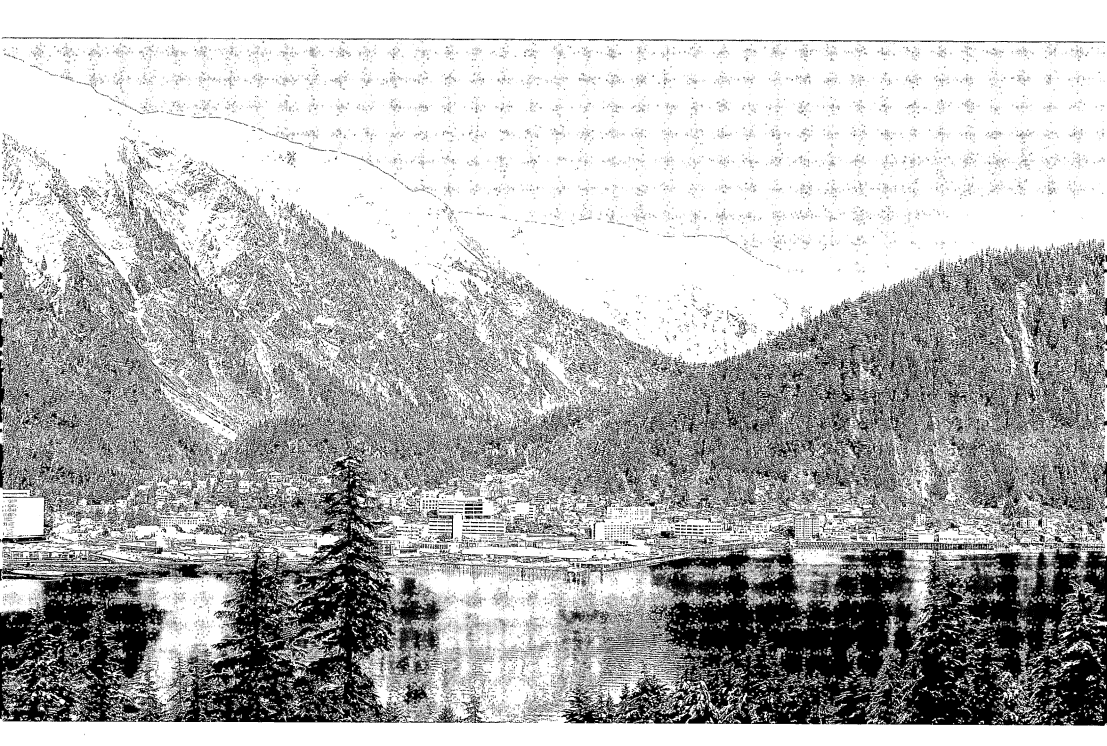

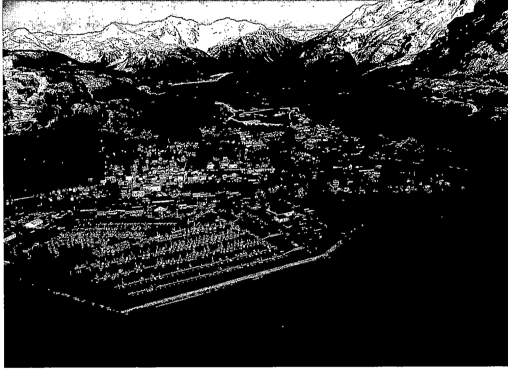

Ketchikan is known by Alaskans as "The First City" because before the era of air travel it was Alaska's first port of call for northbound steamers, and for many of today's travelers it still is. Ketchikan is near the boundary between Tlingit, Haida, and Tsimshian peoples, and its unparalleled collection of Native totems is its most important monument.

Cordova, a small port on Prince William Sound, was once the terminus of a railroad line that carried copper ore from the mine at Kennicott. Since that line was abandoned when the mines closed in 1938, there has been no overland link between Cordova and the outside world, although about fifty miles of the rail line has been paved and provides access to the largest contiguous wetland in the Western Hemisphere.

. . . in these coast landscapes there is such indefinite, onleading expansiveness, such a multitude of features without apparent redundance, their lines graduating delicately into one another in endless succession, while the whole is so fine, so tender, so ethereal, that all penwork seems hopelessly unavailing.

—JOHN MUIR, *TRAVELS IN ALASKA*

 (Houghton Mifflin, 1915)

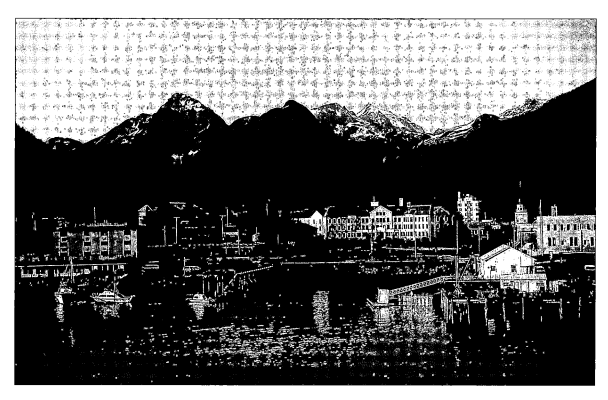

The Pioneers' Home, viewed from a bridge in Sitka, is the town's state-run residence for retired early settlers, who can provide visitors with a valuable oral history of twentieth-century Alaska.

At high tide, the stilted houses of Petersburg's Hammer Slough are reflected perfectly in the still waters of this Norwegian-Alaska town in the southeast.

ABOVE: The Aleutian-range volcanoes to the southwest of Anchorage are active. Here, an eruption of Mount Spurr, eighty miles from the city, can be seen in the distance.

Anchorage residents and visitors enjoy the proximity of the mountains and sea as well as the benefits of living in a cosmopolitan center. Downtown's Town Square is a beautifully landscaped public park with a 1994 mural by Wyland, who has painted similar whale murals in other West Coast cities.

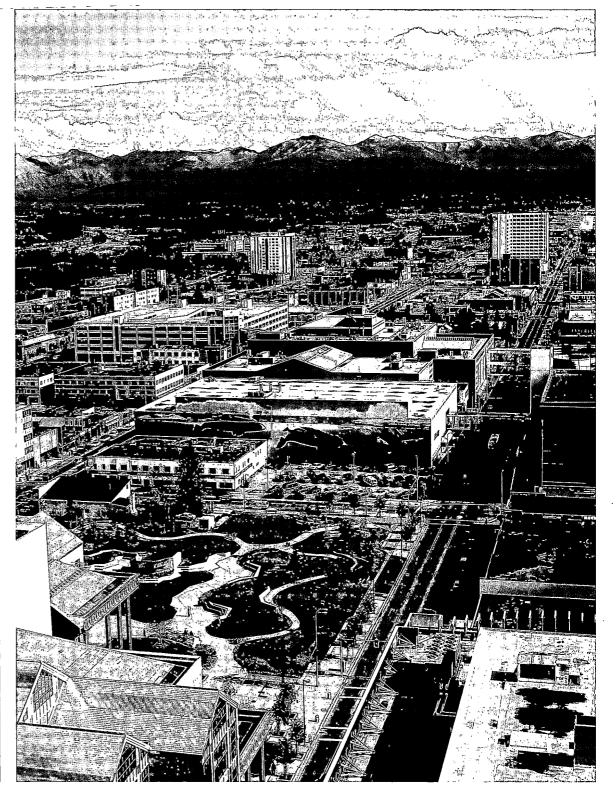

Downtown Anchorage from a distance displays an upreaching skyline that implies great pressure for land. Down below, among the high buildings, are houses, huts, vegetable gardens, and bungalows with tidy front lawns. Anchorage burst out of itself and left these incongruities in the center, and for me they are the most appealing sights in Anchorage. Up against a downtown office building, I have seen cordwood stacked for the winter.

—JOHN MCPHEE, COMING INTO THE COUNTRY
 (Farrar, Straus and Giroux, 1977)

Full moon rising over Anchorage on New Year's Eve

Then very soon the sky is midnight blue and fully spangled with stars,
and the moon is rising brighter and brighter behind the pointed trees.
In the north a flicker of green and yellow, then an unfurled bolt of
rainbow ribbon shivering and shimmering across the stars—the Aurora

—Margaret E. Murie, *Two in the Far North (Knopf, 1962)*